Just Yesterday on the Outer Banks
Second Edition

David Stick and Bruce Roberts

Pineapple Press, Inc.
Sarasota, Florida

Inquiries should be addressed to:
Pineapple Press, Inc.
P.O. Box 3889
Sarasota, Florida 34230

www.pineapplepress.com

Library of Congress Cataloging-in-Publication Data

Stick, David, 1919–2009.
　　　[Cape Hatteras seashore]
　　　Just yesterday on the Outer Banks / photography, Bruce Roberts ; text,
David Stick. — Second edition.
　　　　　　　　pages cm
　　　Previously published as: The Cape Hatteras seashore / David Stick, text
; Bruce Roberts, photography. Charlotte : McNally and Loftin, c1973.
　　　ISBN 978-1-56164-699-9 (pbk. : alk. paper)
1. Outer Banks (N.C.)—Description and travel. 2. Hatteras, Cape (N.C.)—
Description and travel. 3. Outer Banks (N.C.)—Pictorial works. 4. Hatteras,
Cape (N.C.)—Pictorial works. I. Roberts, Bruce, 1930– II. Title.

F262.A19S79 2014
917.56'10444—dc23

　　　　　　　　　　　　　　　　　　　　　　2014006929

Second Edition
10 9 8 7 6 5 4 3 2 1

Design by Bruce Roberts
Printed in the United States

TABLE OF CONTENTS

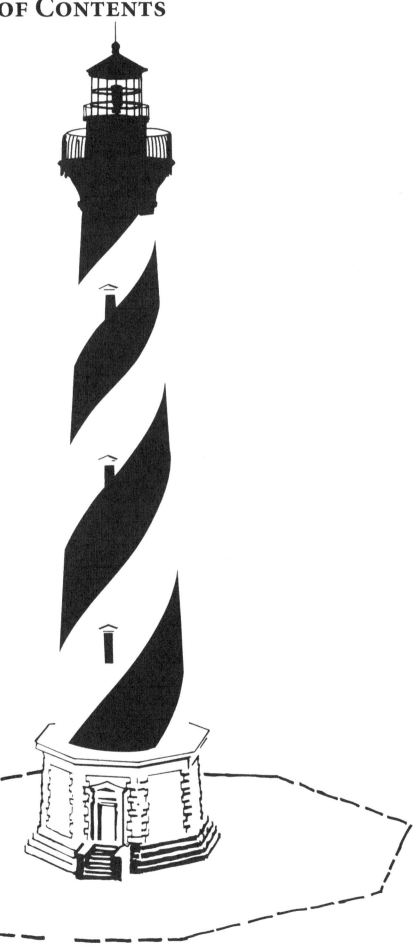

ACKNOWLEDGMENTS

First, I would like to thank my old friend David Stick for writing the copy to go with my photos and for giving me years of advice and help in understanding the nature and people of the Outer Banks of North Carolina.

When I first visited the coast, Aycock Brown was a one-man Dare County Tourist Bureau. He knew everyone on the Outer Banks during the 1960s, when every shipwreck had revealed itself after a storm, and he helped me find pictures to take and the information to go with them. David, Aycock, and I became lifelong friends. I miss them both, but their memories live strong in all who knew them and the pictures and words they left for new generations.

Bill Loftin, owner of McNally and Loftin Publishers in Charlotte, published the first edition of this book in 1964. Thanks to him, it stayed in print for twenty years. He gave me the copyright to the book in order for this new edition to be created.

The Outer Banks History Center in Manteo, a regional archives and research library of the State Archives of North Carolina, was founded in 1989 to house the library and archives of author and historian David Stick. Archivist Stuart Parks retrieved my old negatives and digitally reformatted them to bring them back to life.

John Havel, graphic artist and all-around creative genius and friend, converted my old color slides into new prints that wiped away nearly half a century of dust to make them new again.

Thanks also go to June Cussen of Pineapple Press and her staff for believing in this new edition and getting it in print.

My wife, Cheryl, helped me stumble into the digital age of photography and practiced patience when I kept asking her to do just one more thing to finish this book.

Without these people, this book would not be in your hands.

Bruce Roberts

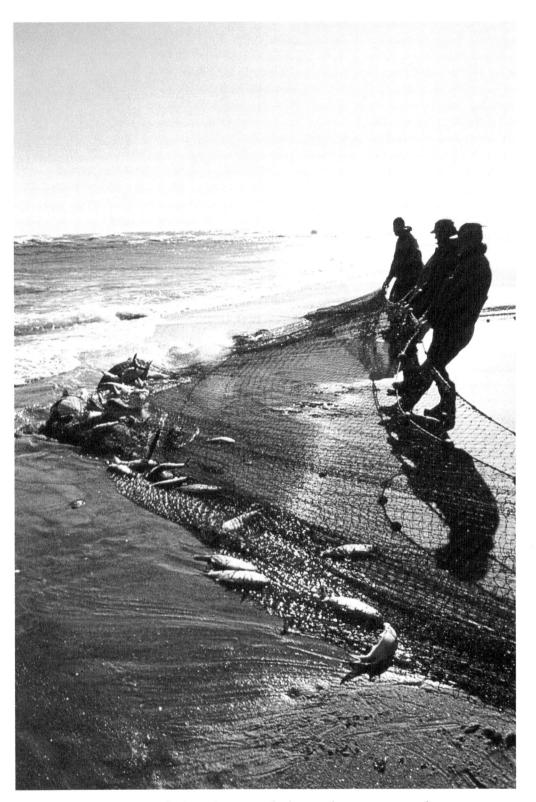

There is an air and a feel and a mood about the Outer Banks Seashore—miles from the mainland—that is distinctive and compelling. The waves that break on the sand have been blown here from Europe, but rather than feeling old there is a sense of new beginnings: The first colony, the first flight, the first radio waves of music were heard here.

Bruce Roberts
David Stick

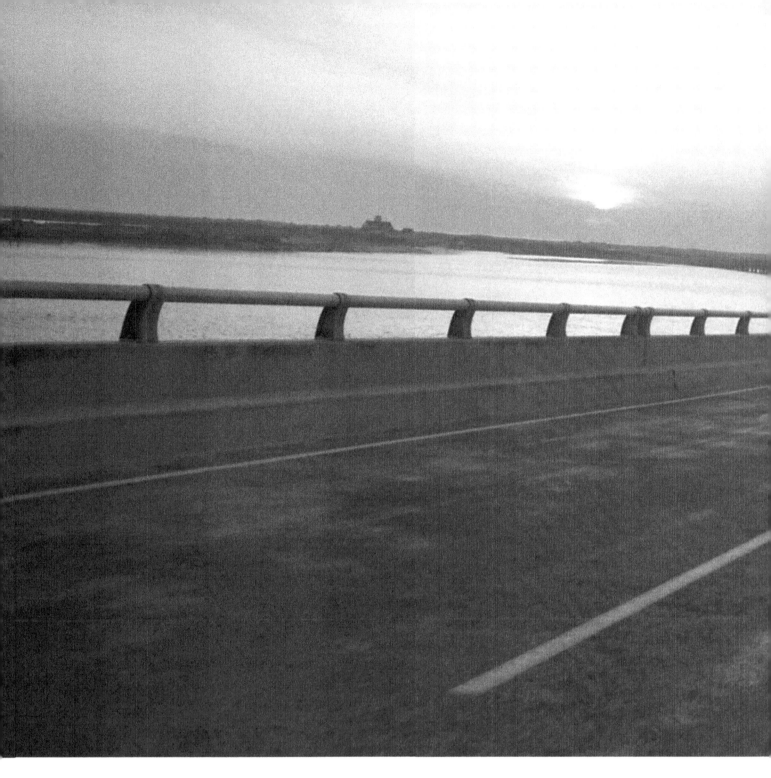

THE GATEWAY

The roadbed gradually pulls away from the oceanfront strand at lower Nags Head, leaving behind the clutter of motels and cottages as it begins to undulate in gentle patterns across the wide stretches of marshland and sandy beach.

In the first light of approaching dawn, a giant blue heron rises from a pond beside the road, flapping his great wings in ponderous effort as if to signal that day has come. A lazy swan raises his long neck, then upends himself, pointing his tail skyward as he searches the bottom of the pond for the day's first morsel. Nearby, a pair of redheaded ducks stand

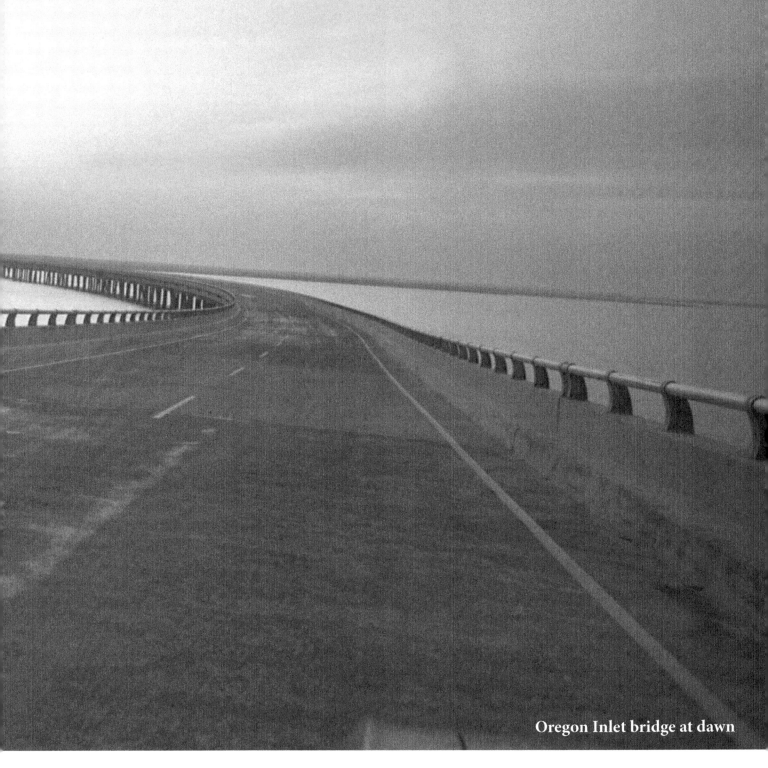

Oregon Inlet bridge at dawn

straight in the water, wildly exercising their wings, then settle back to preen their feathers.

The roadbed straightens, then rises gradually, leaving the marsh and beach behind as it moves out over open water. In the distance, above the low-hanging clouds banked on the horizon, the top of the sun suddenly emerges, lighting the vast sweep of sky and water to pinpoint a thin, dark dividing line that is the land.

Gradually, the silhouette of a Coast Guard station takes shape, dreary and desolate, a reminder of the hundreds of ships wrecked and thousands of mariners lost on this isolated coast in times past. And as the roadbed rises to bridge the inlet channel, the eye picks out the swirling shapes of sandy shoals, fringed with white-capped ocean breakers, providing an incongruous break in the seemingly endless expanse of ocean and sound waters stretching to infinity.

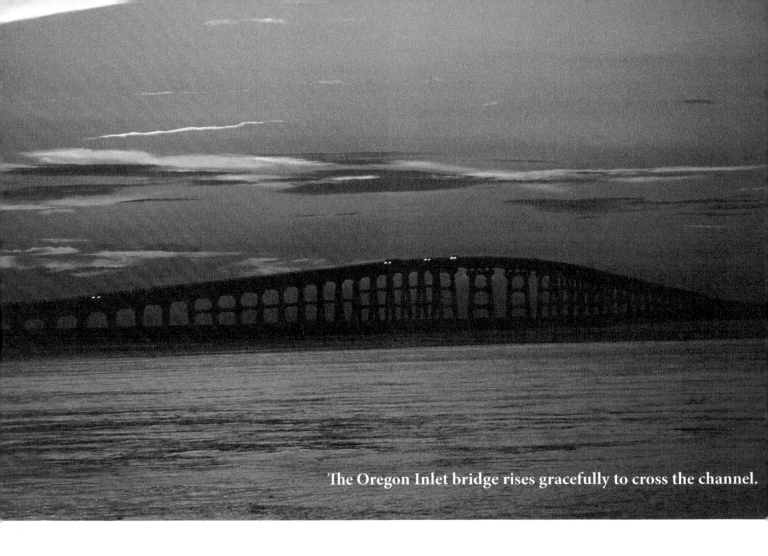

The Oregon Inlet bridge rises gracefully to cross the channel.

This is the gateway to the Cape Hatteras Seashore.

Later, as the lighthouse on Cape Hatteras comes into view, it appears as an alien form, breaking the horizontal symmetry of sea and strand. Its alternate black-and-white spiraling stripes give the illusion of a structure in motion, burrowing into the sand. Then its great size gradually becomes apparent, and a sense of strength and permanence seems imparted, until in time the individual ceases to register surprise at the sight of this lofty, man-made structure rearing its beaconed topknot above the Cape and the treacherous shoals beyond.

For this Cape Hatteras Seashore is a place of balances and counterbalances, of seeming inconsistencies that somehow manage to mesh into a pattern of order. And the Cape Hatteras Lighthouse is a towering symbol of its contradictions.

* * *

There is a spot just north of the Cape where the grass-covered dune between road and sea seems so symmetrical as to have been designed by slide rule and scale and built by engineers and machines instead of by nature. And so it was.

Directly opposite on the sound side is a tranquil cove, its natural curves marred only by a few sandbags along its south shore, as if at one time it had been beset by raging currents that man sought to control. And so it was.

Buried beneath the symmetrical dune are broken bridge pilings and chunks of highway asphalt; hidden under the tranquil cove are the carcasses of dozens of junked automobiles and tens of thousands of hand-filled sandbags. Were Curt Gray still alive, he could

8

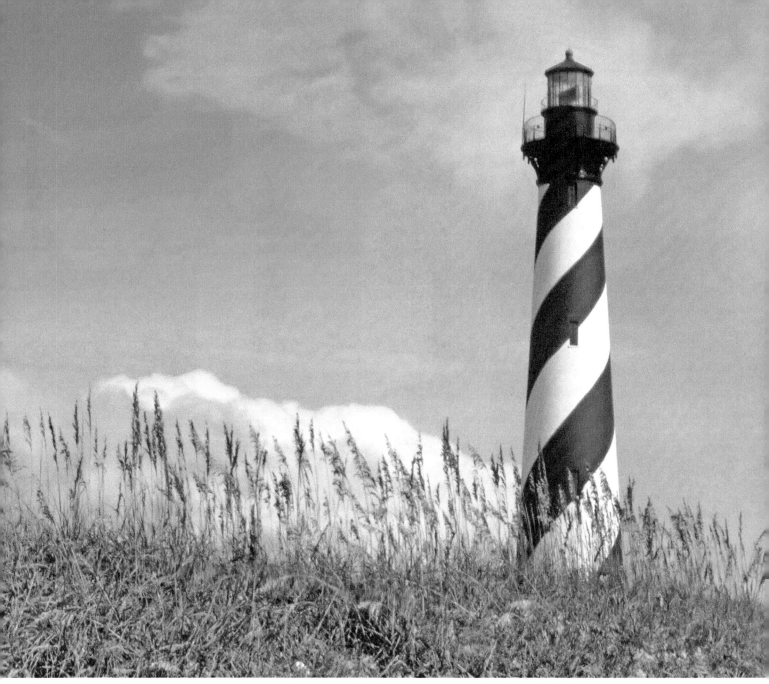

Hand-planted sea oats on a man-made dune shield this country's tallest lighthouse structure at Cape Hatteras.

point to the spot nearby, now water, where the main building of the Buxton Club had stood and, off to one side, the original location of the caretaker's house, in which he and his family had been swept toward the open sea in the backlash of the hurricane of 1944. And someplace nearby, hidden from the probings of

men and Geiger counters, is a giant bulldozer that vanished in the Ash Wednesday storm of 1962.

To the residents of the nearby villages of Buxton and Avon, who disagreed with typical Hatteras Island vehemence over whether it should be closed or left open, this was the Buxton Inlet—opened March 7,

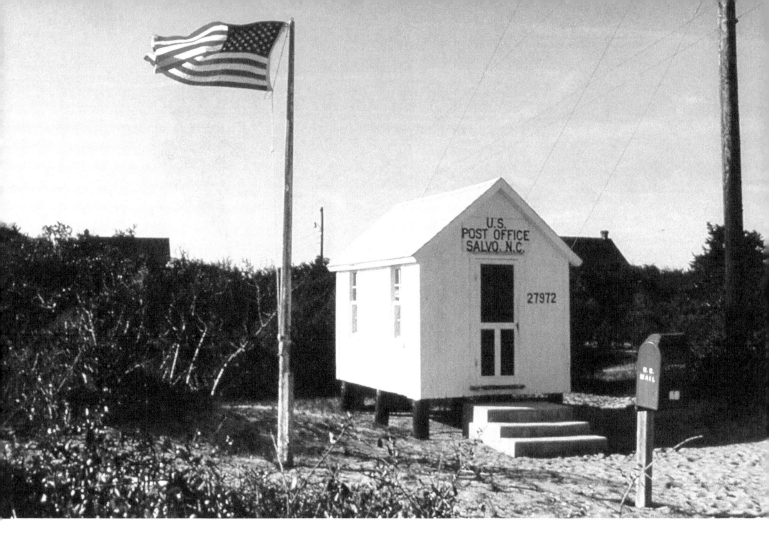

The Salvo post office was once known as Clarks. Other present-day villages' names have changed over time: Rodanthe and Waves, known earlier as Chicamacomico; Buxton, formerly the Cape; and Avon, originally Big Kinnakeet.

1962, by the violence of the Ash Wednesday storm, enlarged in a northeaster that November, and finally closed in the spring of 1963 through the combined efforts of U.S. Army engineers, federal money, two dredges, hundreds of volunteers, and the sandbags and junked automobiles.

To Curt Gray, who lived there, and to the northern sportsmen who came for the famed Pamlico Sound gunning in the declining years of the Great Depression, this was the Buxton Club. The exterior of its clubhouse was covered with machine-made log siding, its interior decorated simply, and the flatness of the grassy front yard broken by imported royal palms, which withered and died in the alien surroundings.

To cartographers of an earlier age, this same spot was the Haulover, a low, narrow stretch of bald beach where fishermen could move their small boats from sound to sea and back again with a minimum of effort, and where the waters made natural passage in times of storm and flooding tides.

Earlier, before Avon had been chosen by some unromantic post office official as the new name for

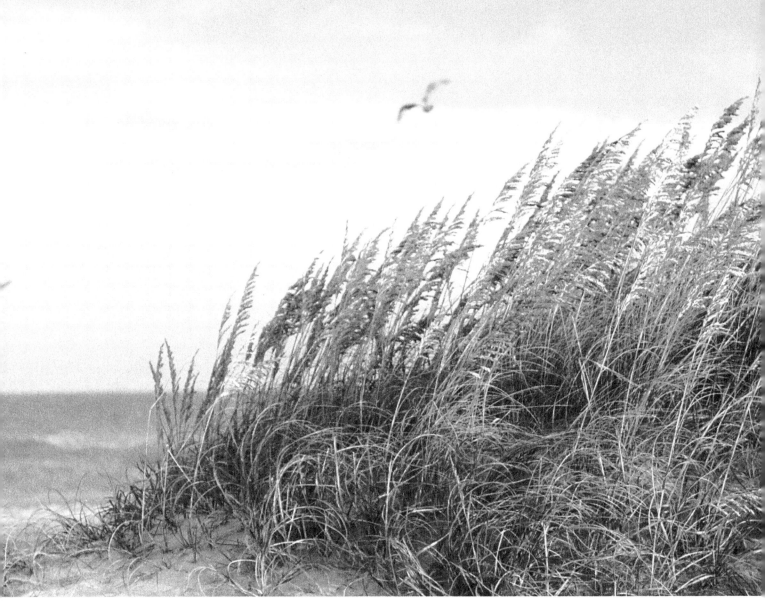

Sea oats near the Bodie Island Lighthouse wave in the wind.

Kinnakeet, and Buxton, for the older community known as the Cape—no, earlier than that even. Before there was a Kinnakeet or a community of European-born settlers at the Cape, there undoubtedly was an ancient inlet at the same spot. And no one can say with certainly that there won't be still another inlet there in the future.

But today there is only the symmetrical sand dune, the tranquil cove, and the modern high-speed highway between, without so much as a sign or a cross to mark what once was there.

It would take many signs, and even more crosses, to mark all such changes that have altered the topography of the Cape Hatteras Seashore. For the face of this atoll-like sandbank is as subject to change as the coloring of a dying dolphin, boated in the nearby Gulf Stream.

THE GRAVEYARD

On occasion, the wind and the tide play tricks on man, laying bare the graves of people buried in long-forgotten cemeteries along the seashore. More often, the skeletons they uncover are the wrecked hulls and broken timbers of old sailing vessels, buried there also. For this is the Graveyard of the Atlantic.

There are no headstones or nameplates to mark the graves, though many of the names are known: *America* and *British Splendour*; *Pennsylvania, Virginia,* and *New Jersey*; *City of New York, City of Atlanta,* and *City of Birmingham*; *Narragansett, Key West,* and *Elm City,* wherever that was.

Frequently, sailing ships backed up north of Cape Hatteras—ten, twenty, sometimes as many as fifty at a time—unable to make headway south around Diamond Shoals against the combined forces of the Gulf Stream current and the steady southwest winds. Lookouts on shore would sit for hours, watching them tacking back and forth like restless lions caged in a zoo, waiting to make their break for freedom. And when that break came, the shift of wind to north or east as often as not scattered the vessels along the coast or wrecked them on the shore. Only the names remained: *Desert Light, Black Squall,* and *Lady Drake*; *Racer, Eagle,* and *Driver*; *Congress, Victory,* and *Pioneer*.

Laden with every conceivable cargo, bound for ports around the world, they seemed to congregate on this isolated spit of sand, like ladies drawn to the bargain counter for the Saturday morning sale: *Laura A. Barnes, Minnie Bergen,* and *Lucy Russell*; *Teresa, Florence,* and *Louise*; *Priscilla, Blanche,* and *Martha*; *Jane, Iona,* and *Belle*.

There were brigs, barks and barkentines, ships and sloops, and schooners with two masts and three and sometimes four, five, and even six. Large or small, old or new, freshly painted

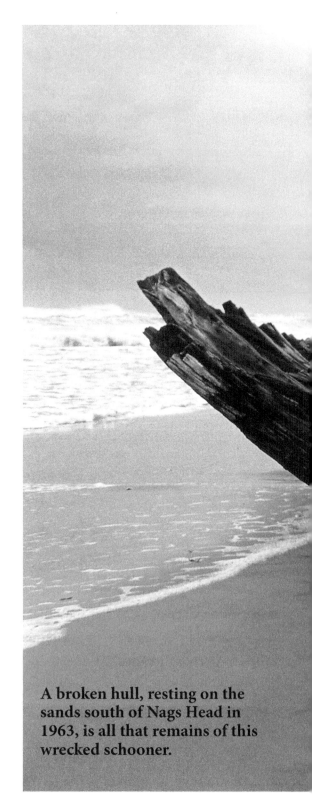

A broken hull, resting on the sands south of Nags Head in 1963, is all that remains of this wrecked schooner.

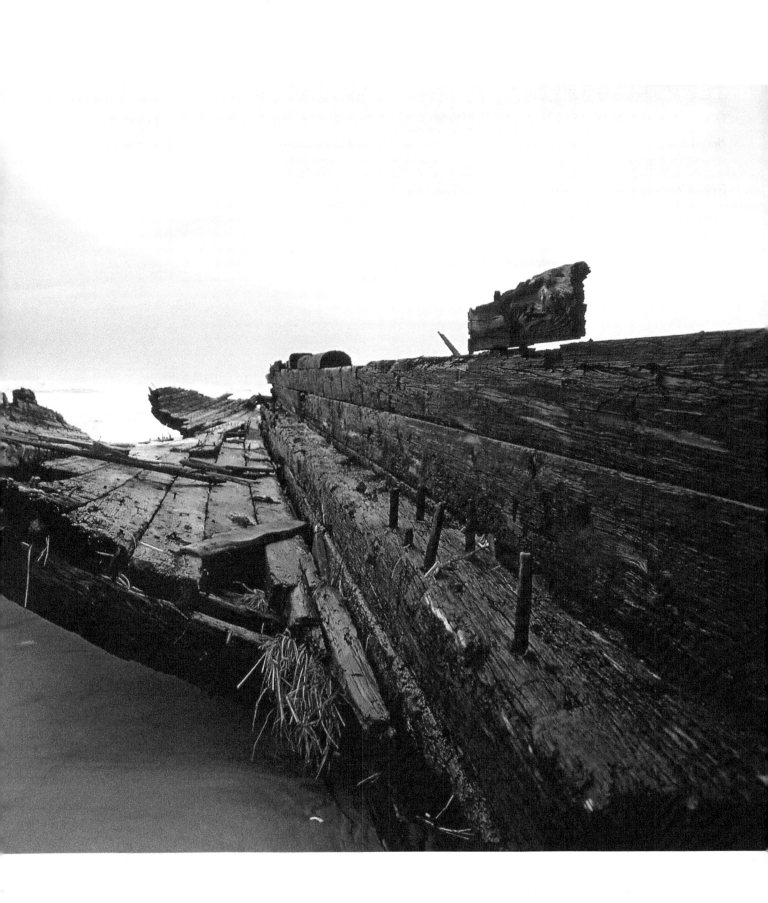

or faded and frayed, it made no difference, for each seemed destined to leave its nameplate on the sand of Hatteras, and some of the proudest of those names were of men: *Byron D. Benson, William J. Watson,* and *A.L. & M. Townsend; A.S. Willers, B.T. Martin,* and *G.W. Carpenter; William Gibbons, Robert Walsh,* and *Benjamin Dickerman; Henry, Ezra,* and even *Horatio.*

In storm after storm, they piled up on the beach, from Chicamacomico to Kinnakeet, from Frisco to Wococon. The pounding surf tore them asunder, scattering their timbers the length of the seashore, some now exposed, many more covered by the drifting sands.

Oak and cedar, mahogany and teakwood, held together with hand-hewn pegs, iron spikes, bolts, and rivets, no two pieces alike, few with clues to their original identity. Offshore, on the shoals of the Outer Diamond, the outlines of unknown hulks lie partly exposed one day but disappear the next. Mysterious and fascinating are these symbols of the Graveyard of the Atlantic.

Nameplates on cottage walls (below and opposite top) are grim reminders of past disasters.

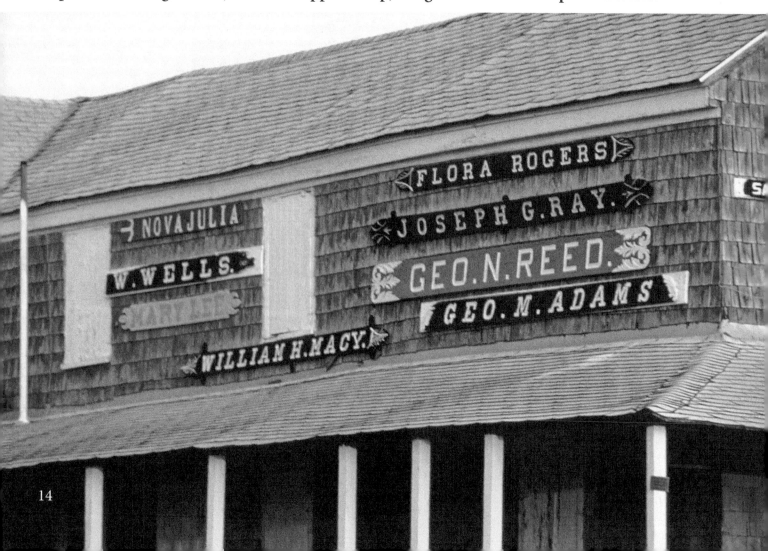

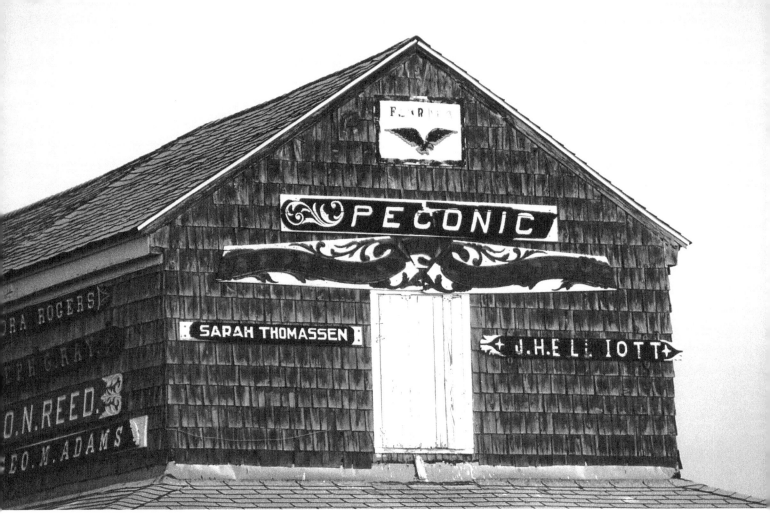

The nameplates once graced proud ships that now are reduced to a few weathered scraps of timber such as these.

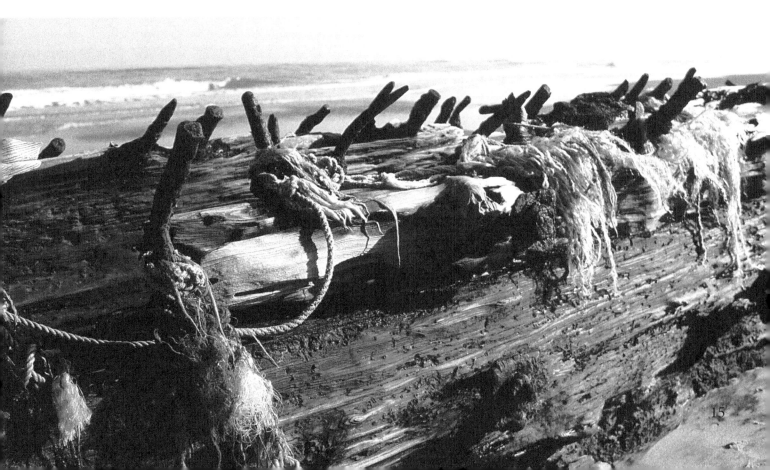

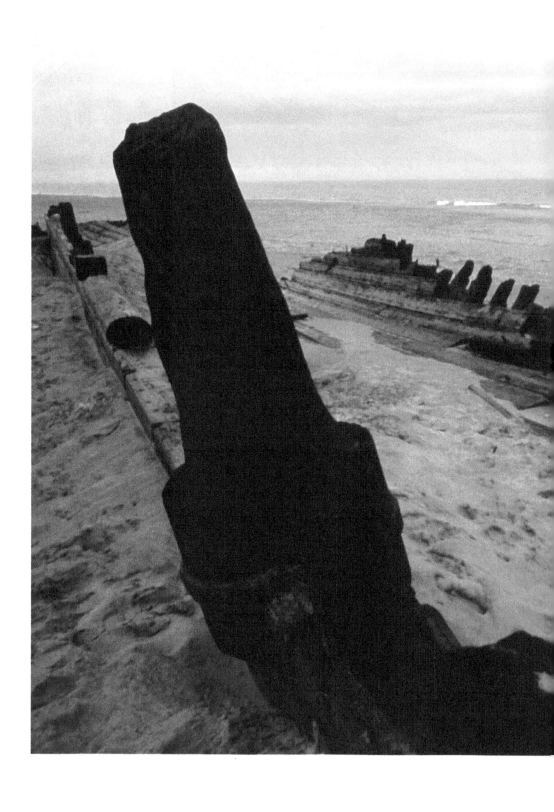

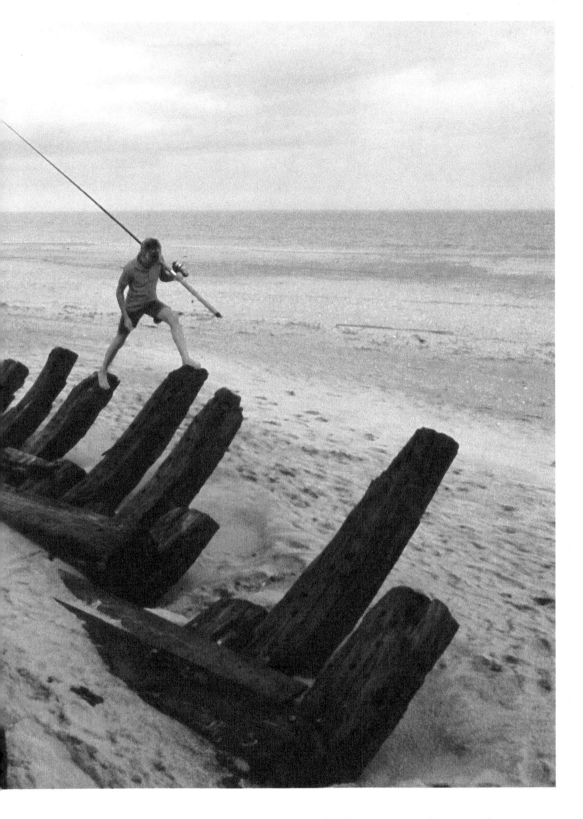

These are the remains of the *Laura A. Barnes,* a schooner that wrecked on Bodie Island on June 1, 1921. All of the men onboard were saved.

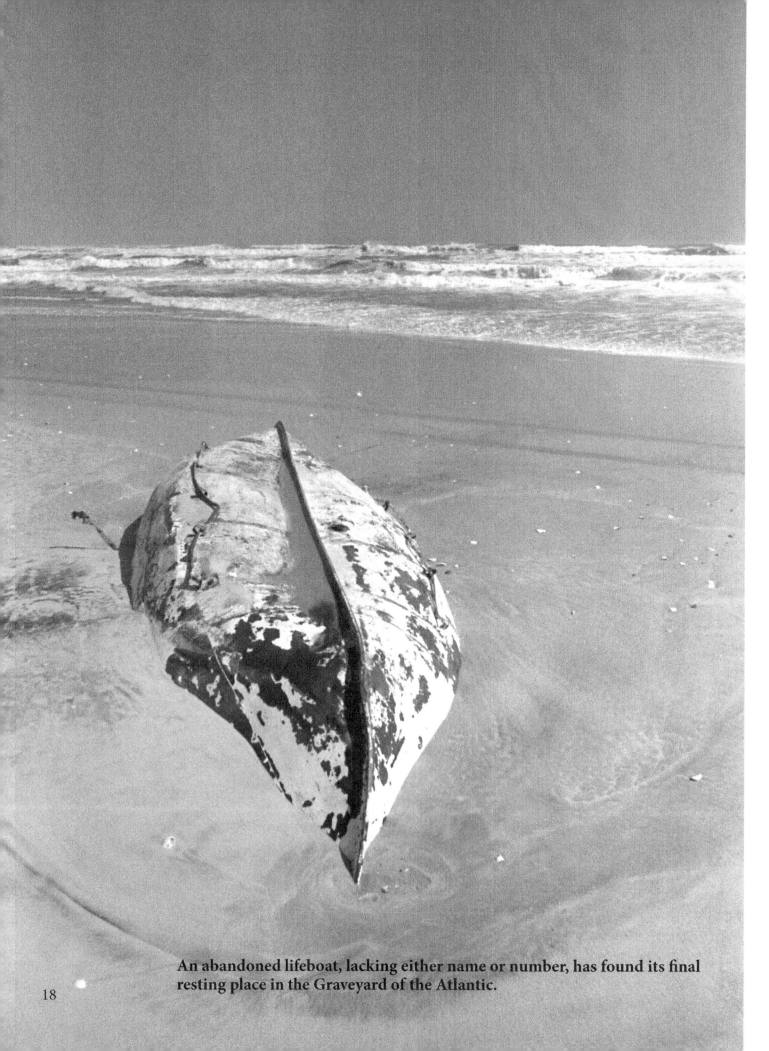

An abandoned lifeboat, lacking either name or number, has found its final resting place in the Graveyard of the Atlantic.

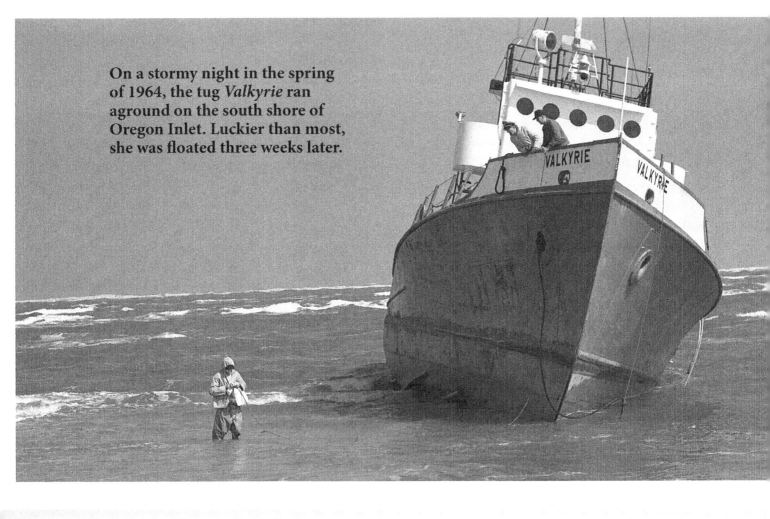

On a stormy night in the spring of 1964, the tug *Valkyrie* ran aground on the south shore of Oregon Inlet. Luckier than most, she was floated three weeks later.

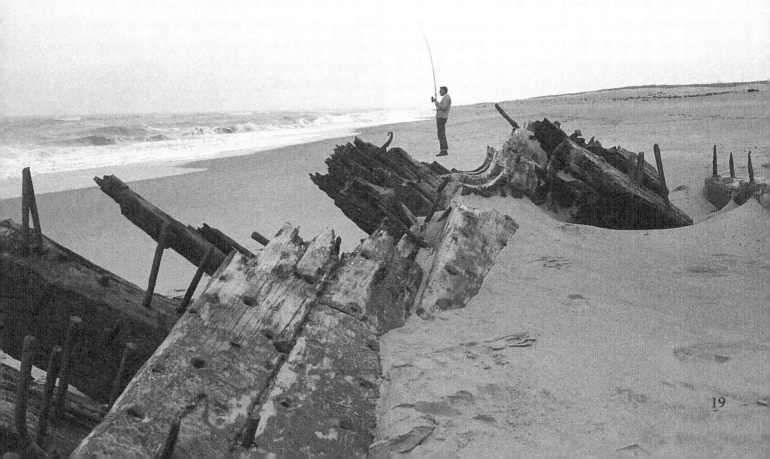

The ever-moving sand exposes the broken ribs of yet another vessel wrecked in a bygone era.

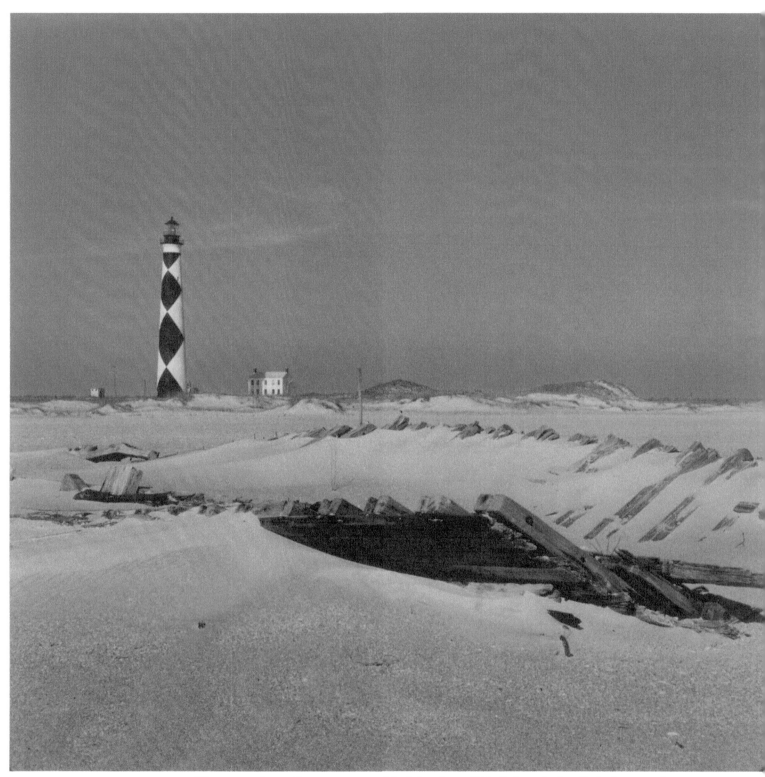

The remains of a century-old ship that didn't heed the light's warning rest near the Cape Lookout Lighthouse.

A World War II "landing ship, tank," or LST, was lost on Hatteras Island after the war as it was being towed to a shipyard.

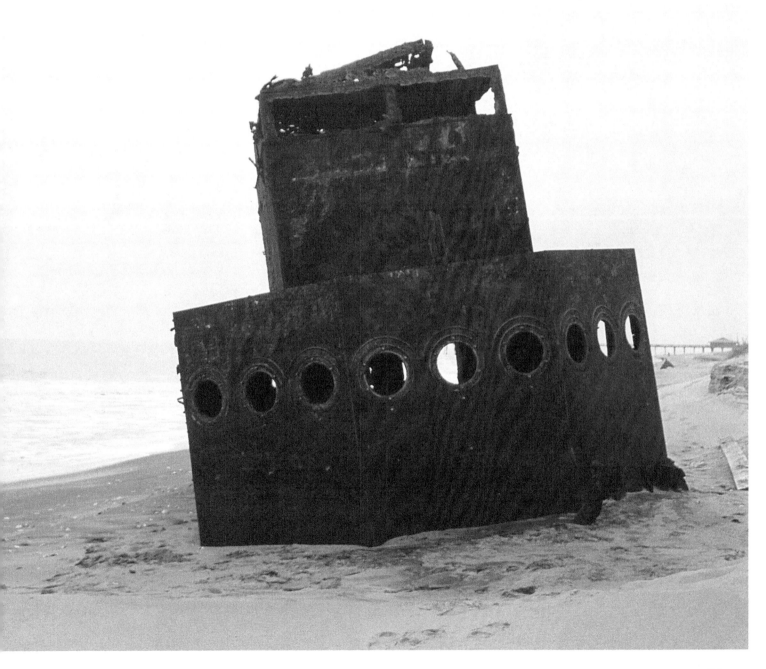

Like an eerie subterranean cave, the interior of this World War II wreck is slowly claimed by the elements.

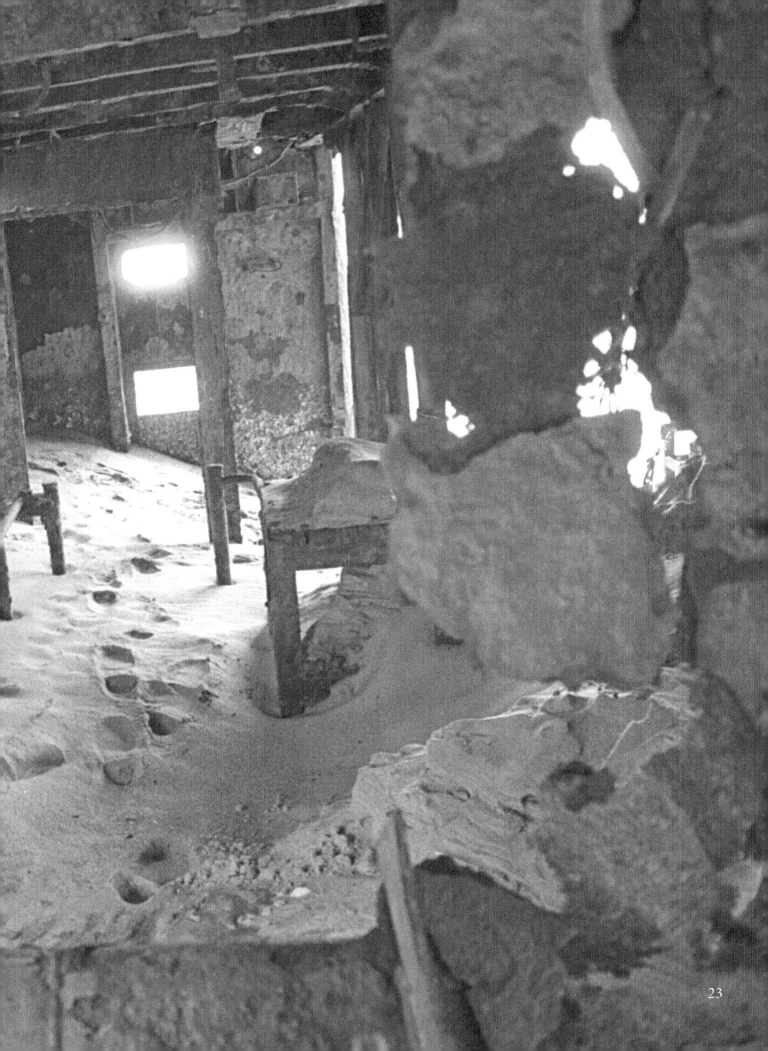

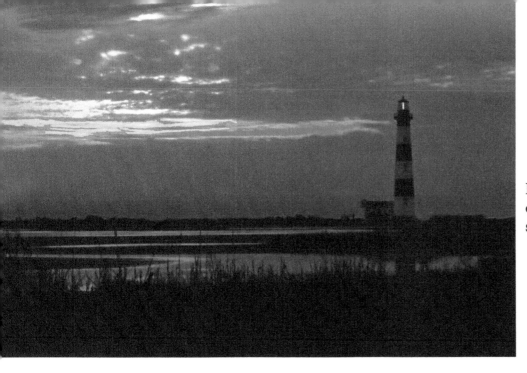

Bodie Island Lighthouse at dusk as seen from Highway 12 south of Nags Head.

LIGHTHOUSES

Only the strong of heart climb the lighthouse at Cape Hatteras, and only the least inquisitive fail to count the steps of the spiraling stairway to make certain there really are 268 of them, as the architects claimed.

Many are the bold explorers who, having a dizzying fear of the climb, emerge with exuberant pride through the doorway above step number 268, only to quail at the prospect of stepping out on the open platform surrounding the lantern 175 feet above the level of the sea below.

Yet for those who take this final step, there unfolds a vista long remembered: a panoramic view of the Cape itself and the turbulent water above Diamond Shoals; of the narrow spit of sand stretching northward into nothingness; and of the dense woods to the west that shield the villages of Buxton and Frisco, with the broad and seemingly unlimited breadth of Pamlico Sound beyond.

It is easy then to understand how the early sixteenth-century explorers, setting European feet on this sandy bank for the first time, imagined it an isthmus, a fragile connecting link between continents to north and south, and a thin barrier separating the Atlantic from the great Western Seas.

* * *

The lighthouse at Cape Hatteras is not the only one in the seashore area, though it is taller and better known than those of Ocracoke and Bodie Island, and the purpose in constructing the lighthouses was not so much to see from as to be seen. The intent was to place them sufficiently close together along the shore so that coasting vessels could spot the next one ahead before the last one had disappeared astern. Each was equipped with a distinctive light, usually flashing at regular intervals or in unusual cadence, so one could be distinguished from the others at night, while the shape, height, and markings of each provided immediate identification by day.

The lighthouse at Ocracoke, built in 1823 and the oldest on this coast, was designed originally to provide guidance for vessels seeking entry through the then-busy Ocracoke Inlet into the Port of Beacon

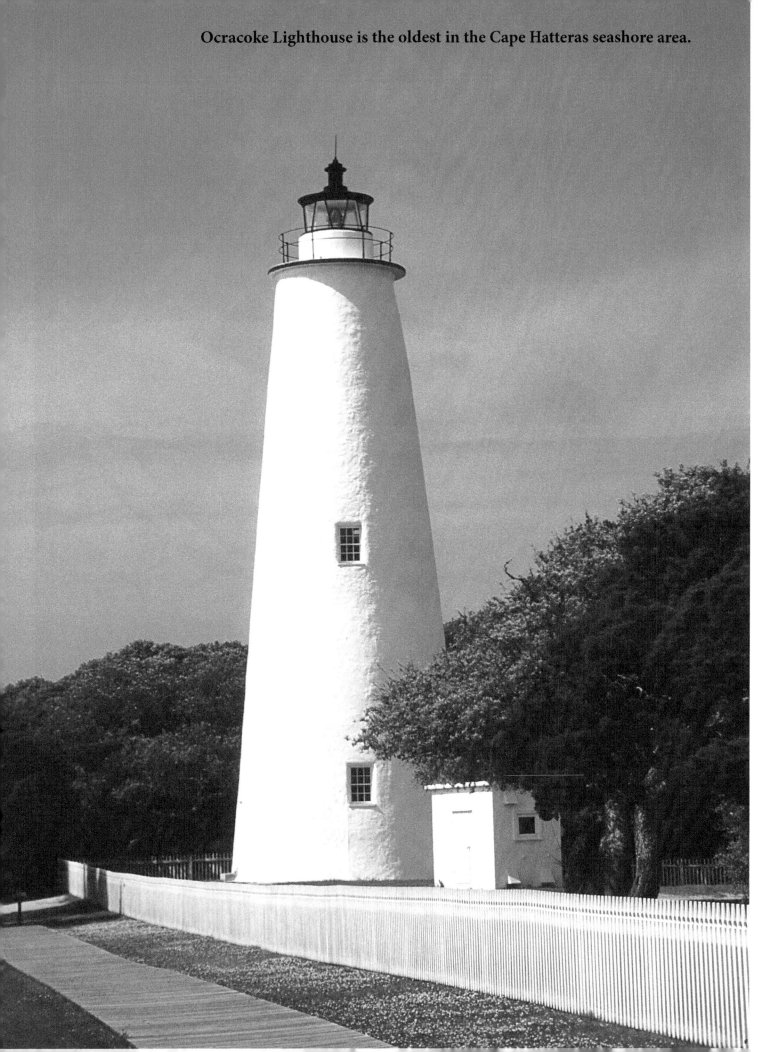

Ocracoke Lighthouse is the oldest in the Cape Hatteras seashore area.

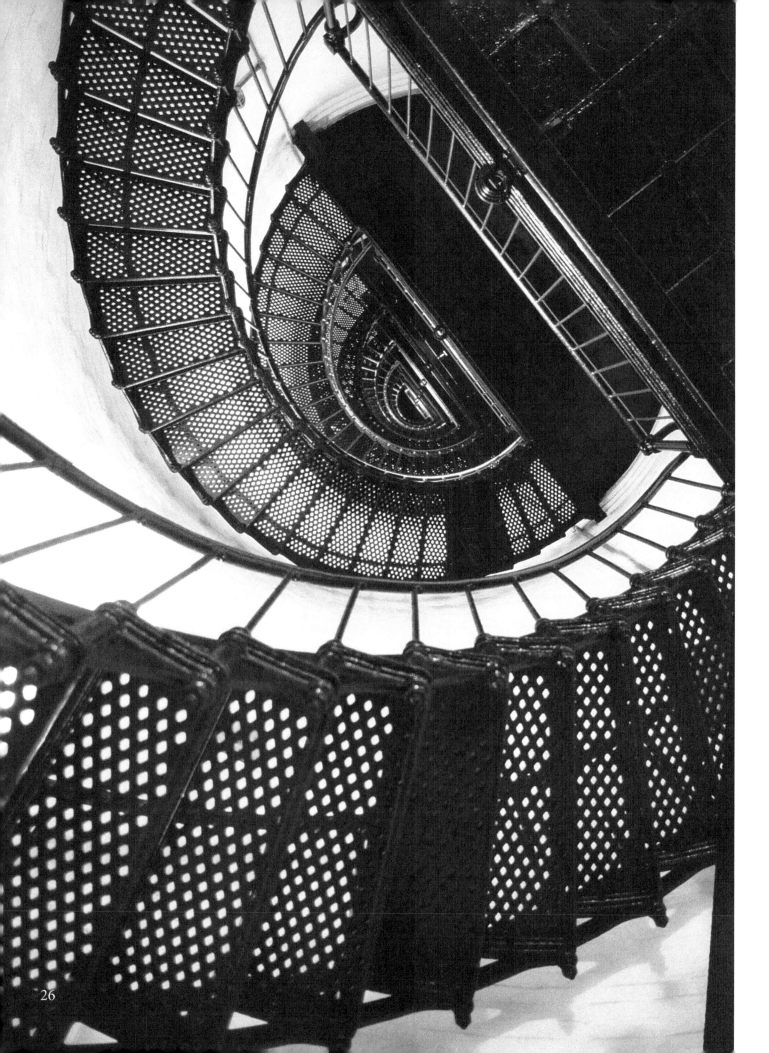

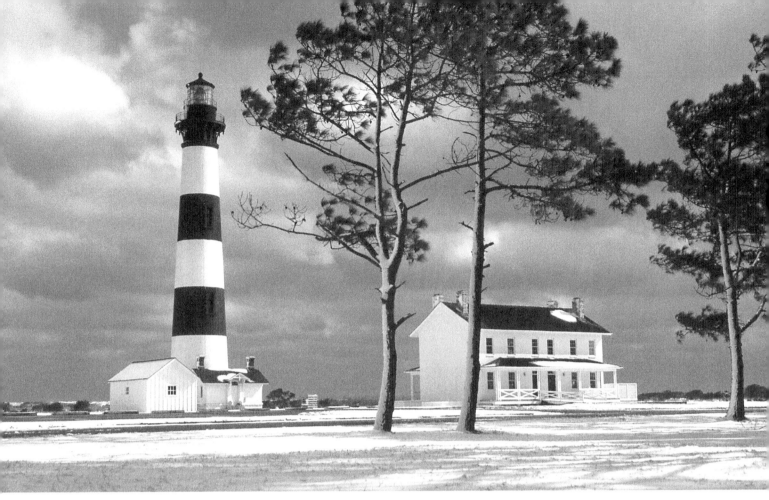

A rare snowstorm turns the Bodie Island Light Station into a winter wonderland (above).
A summer moon rises behind the tower (below).

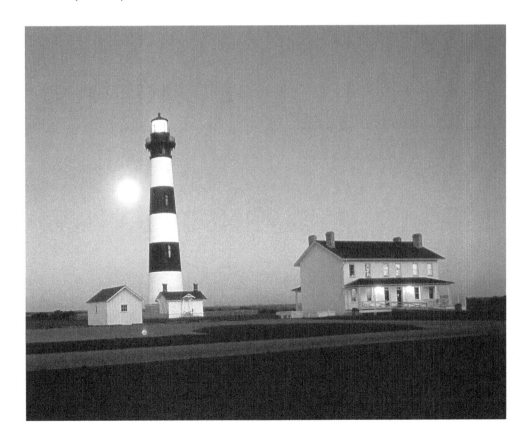

(opposite) Walking to work was an uphill journey for a keeper at the Bodie Island Lighthouse.

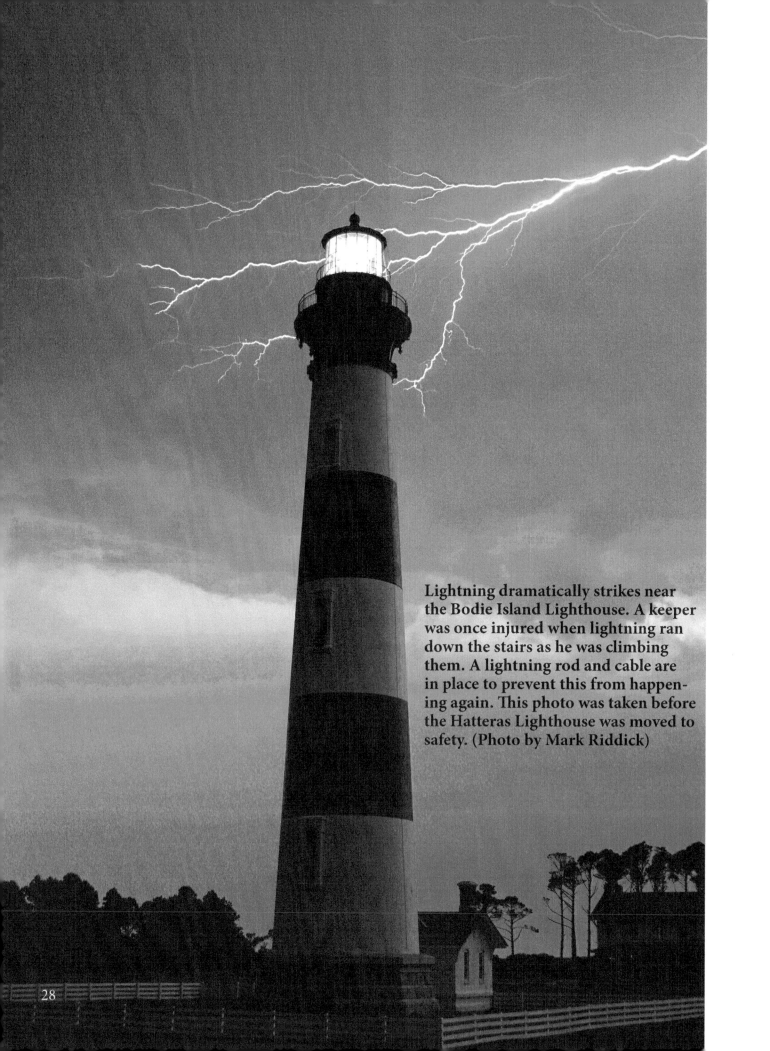

Lightning dramatically strikes near the Bodie Island Lighthouse. A keeper was once injured when lightning ran down the stairs as he was climbing them. A lightning rod and cable are in place to prevent this from happening again. This photo was taken before the Hatteras Lighthouse was moved to safety. (Photo by Mark Riddick)

Island Roads, the latter a name long forgotten. Its conical shape and stark white exterior gave bearings to an average of more than one hundred oceangoing sailing vessels entering the inlet each month during the busy 1840s.

It has been witness to and survived a civil war, two world wars, and an almost continuous sequence of Cold War scares in between the hot ones. It was there to welcome the first lifesaving crew to take up station on Ocracoke, as well as the lifesavers' successors, the Coast Guardsmen. It was the beacon toward which the steamer *Home* was headed when it wrecked on Ocracoke in 1837 with the loss of ninety lives. Since then, it has provided reassurance and encouragement to hundreds of mariners whose vessels struck ground and went to pieces on the beach within the reach of its beaming light.

In the days when whale oil provided the fuel to light the lanterns behind their reflecting lenses, the Ocracoke light shone nightly on the shallow waters of Cockle Creek, where the pilots and fishermen tied up their small craft safe from storms. Later, when kerosene replaced whale oil—and later still, when electric lighting devices were installed—it shone on, night after night from dusk until dawn, as regular as the rise and fall of the tides and the change of the seasons. It was on duty when the dredges came to dig out Cockle Creek and convert it into beautiful Silver Lake, when the first airplane landed on the flats opposite the village, and when the ferry *Sea-level* made its initial crossing from the mainland, loaded with cars and celebrants.

It has outlived keeper after keeper and was old by human standards when the eldest of the villages' present-day residents was born beneath its light. By those same standards, some suggest that it may even have outlived its own usefulness. But those who so speak must never have sat on the docks at Ocracoke on a summer evening and felt their very souls permeated by peace and goodwill as they watched the reflection from that light dance across the placid waters of Silver Lake.

* * *

While Ocracoke Lighthouse is conical and white, the light at Bodie Island is tall and slim with broad, alternating black-and-white circular stripes. From the base looking upward as the white clouds scud by overhead, one marvels at the audacity of man in even planning such a structure on this isolated outpost more than 150 years ago, when every piece of stone had to be brought across the shallow sounds by sailboat and every storm tide washed the beach on either side. But plan he did, and build he did, and even in this age of rocket travel the lighthouse remains a majestic thing of permanence in a land of constant change.

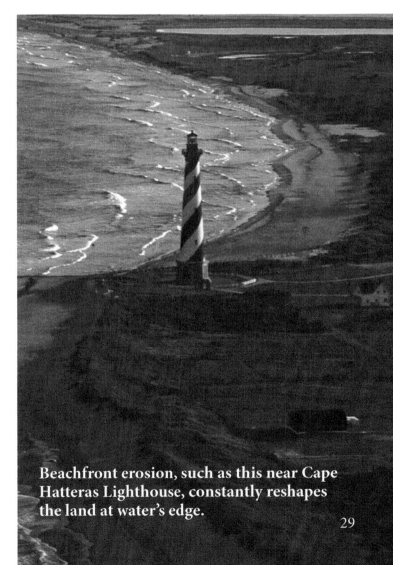

Beachfront erosion, such as this near Cape Hatteras Lighthouse, constantly reshapes the land at water's edge.

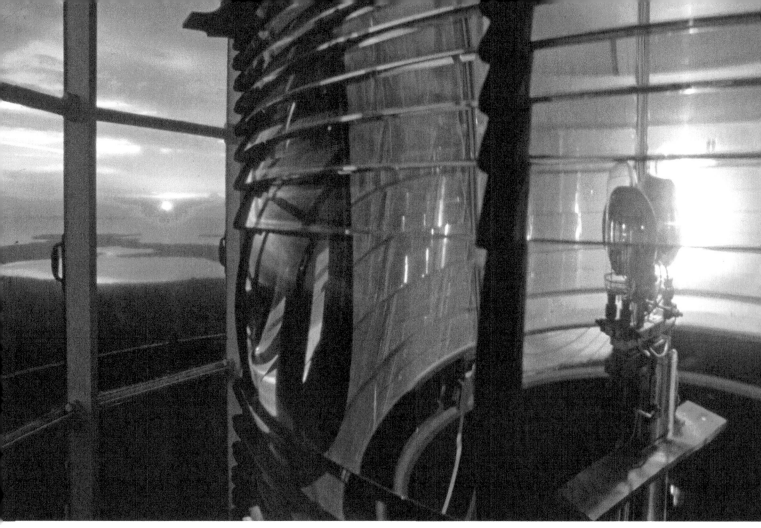

A 1,000-watt electric bulb serves where once an oil lamp was placed (above). In the background, a setting sun gleams across Currituck Sound.

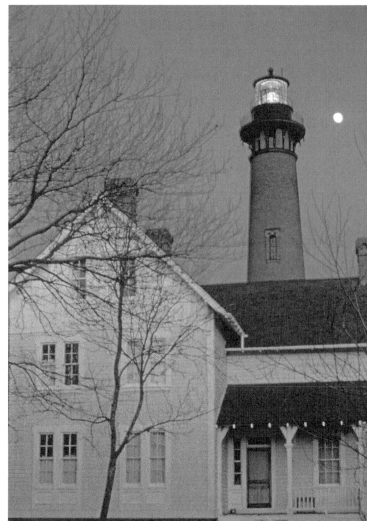

The Currituck Beach Lighthouse was the last tall coastal lighthouse built in North Carolina by the U.S. Lighthouse Service. Its beam of saving light broke the darkness between Bodie Island to the south and Cape Henry to the north. The Outer Banks Conservationists, Inc., has restored the 1875 tower and keepers' quarters to their original elegance.

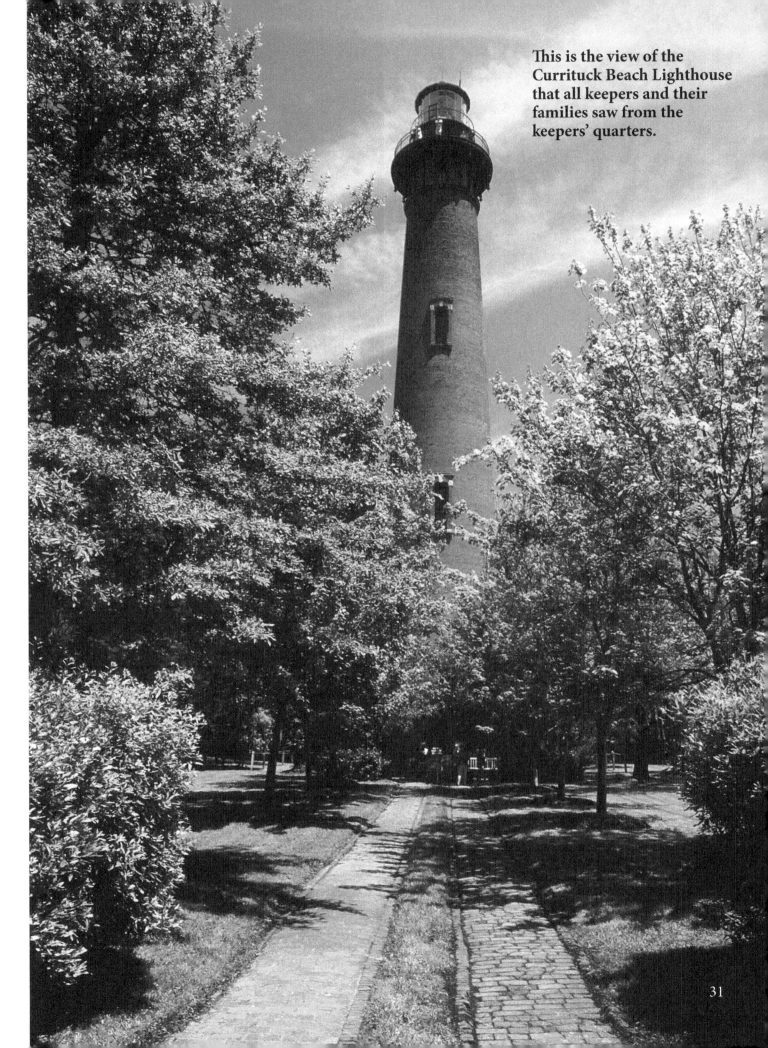

This is the view of the Currituck Beach Lighthouse that all keepers and their families saw from the keepers' quarters.

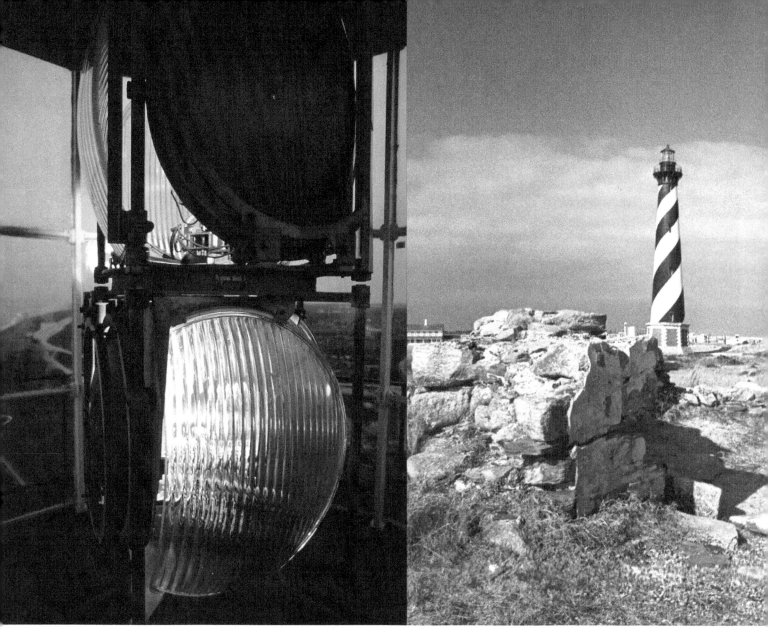

Carlisle-Finch lenses were in use at the Cape Hatteras Lighthouse during the early 1960s when this picture was taken. In this view from the lantern room (left), the path leads to the ruins of the 1803 tower (right). These stones are now underwater.

(opposite) The Cape Lookout Lighthouse was built in 1859 by W.H.C. Whiting, a West Point graduate and member of the Army Corps of Engineers. It was one of the first tall, coastal lights on the East Coast. The black diamonds, originally known as "checkers," face north-south while the white diamonds face east-west, a unique daymark for any American tower. At the time this picture was taken in the early 1960s, the first-order Fresnel lens was still operational.

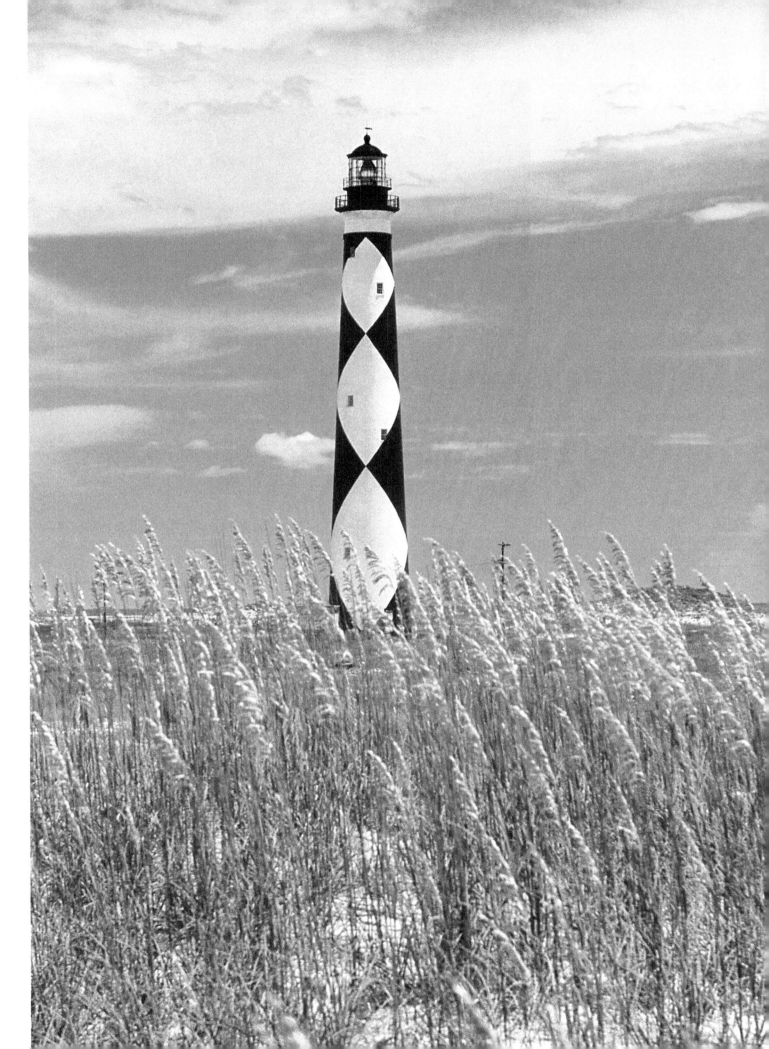

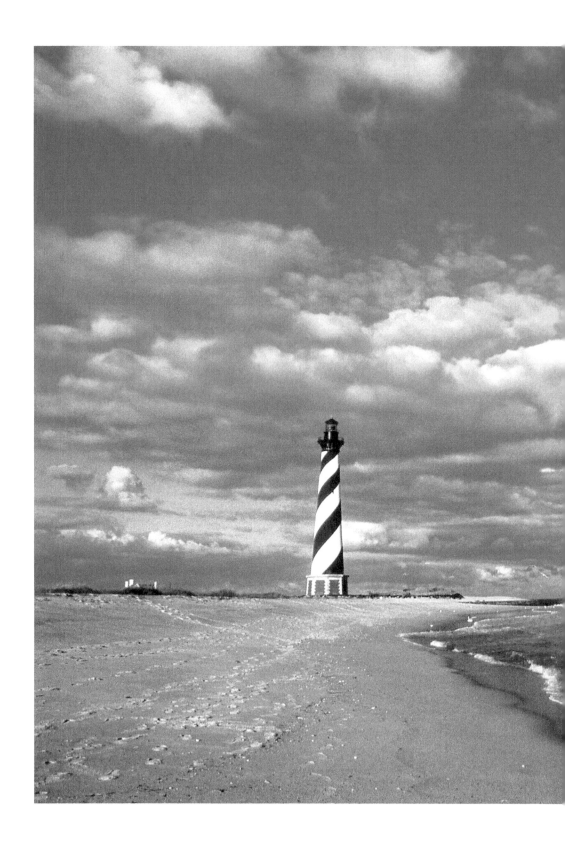

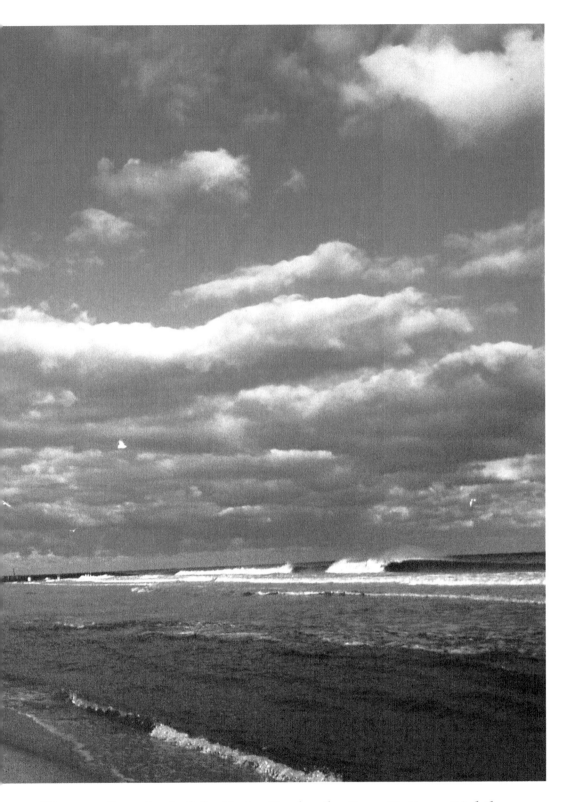

The grand sentinel of the Outer Banks, the Cape Hatteras Lighthouse, stands defiantly in the face of approaching waves. For more than 110 years, it was threatened by erosion and had to be relocated 2,900 feet to the southwest in 1999.

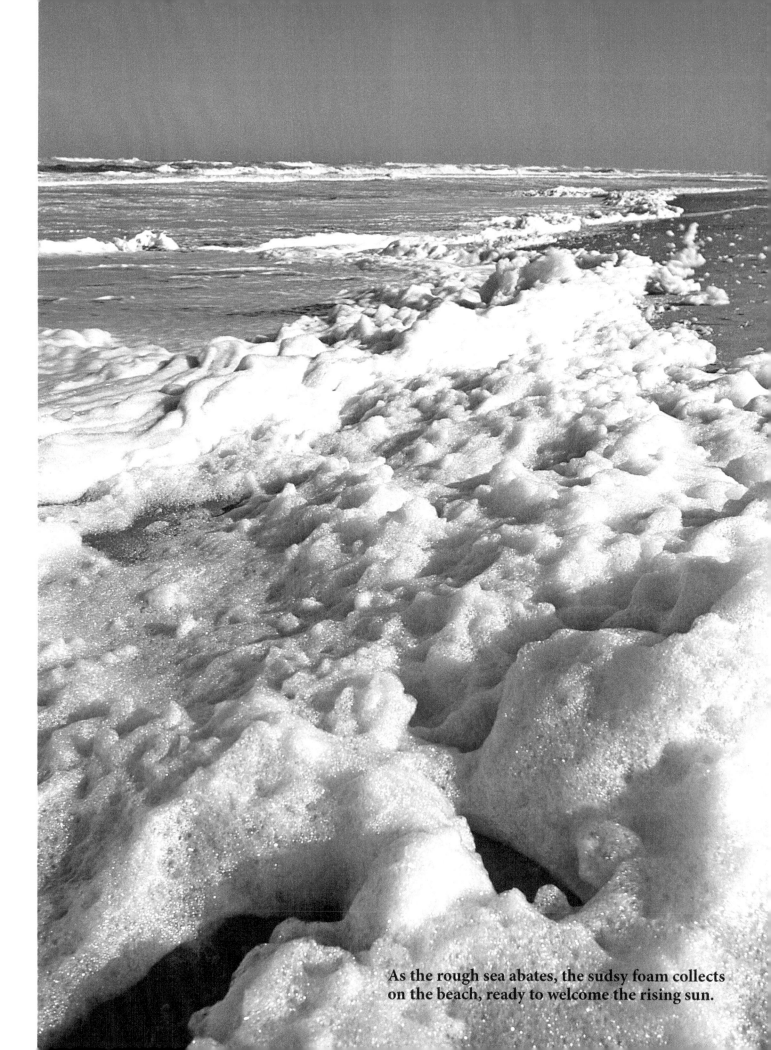

As the rough sea abates, the sudsy foam collects on the beach, ready to welcome the rising sun.

THE SEA

I have looked at the sea a thousand times, from the same spot and through the same eyes, and I have seen a thousand different seas.

I have seen the sea at dawn in spring, mirroring the initial brilliance of daybreak on its calm surface, tranquil and unruffled in the stillness of the moment. I have felt the first touch of morning breeze and seen the little ripples form on the surface, growing larger into wavelets at the steady urging of the breeze.

I have seen the sea in the heat of summer, its clear water glistening above the bar, tempting the weak human to submerge in its cool depths and rinse away the accumulation of sweat and grime and earthly cares, and then float in blissful ecstasy upon its inviting surface. And I have waited on the outer bar to catch a ride on a gentle roller—feeling the exhilaration only the body surfer knows as he breasts the wave toward shore—and then sprawled there on the sand, my chest heaving, sensing a close kinship to the sea as it too breathed in steady rhythm as the ground swells passed beneath.

I have seen the sea in an autumn hurricane, fetching its giant rollers from far beyond the limits of perception, each comber pulled by frothing white horses straining to smash it against the shore. I have watched with awe as solid sheets of spray detached themselves from the massive waves to plaster shore-front structures. And I have felt its salty sting as I cautiously peered out from my place of concealment.

I have seen the sea in winter, cold and bleak and uninviting, warning all to stay away until its angry mood has passed. And at such times, having gained knowledge of its ways and respect for its power, I have stayed away.

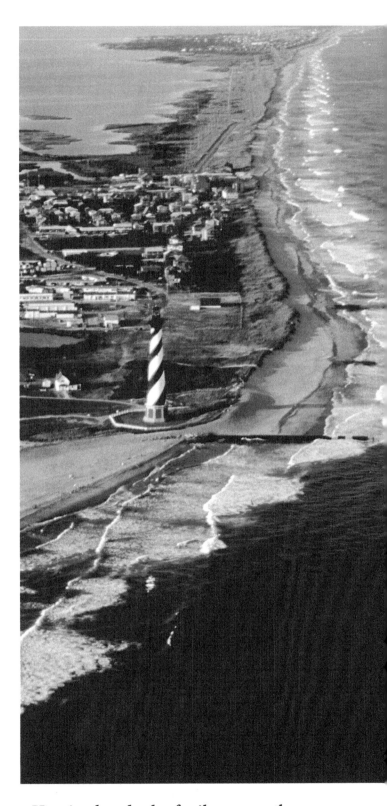

Heaving hundreds of miles across the open sea, the waves come to rest at last on the shores of Hatteras Island.

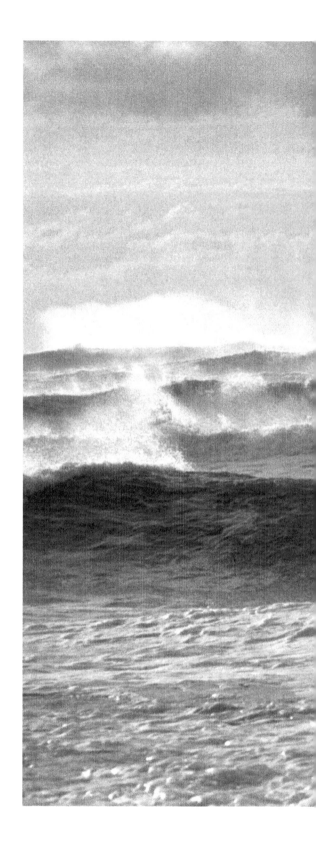

THE FICKLE WIND

How fickle the wind on the Outer Banks!

One moment it gently caresses your cheeks with a soft touch of southwesterly breeze, cooled by its approach across wide expanses of open sound.

Then comes a shift of wind, sudden, dramatic, shocking in its fury. Ominous black clouds appear without warning to north and west, as if dropped from the heavens to shroud the earth, and in the unexpected darkness comes the furious blast of cold air, clammy and possessing.

The dwarf oaks and myrtles and yaupon huddle against the onslaught, while the tall pines dip their long-leafed tops

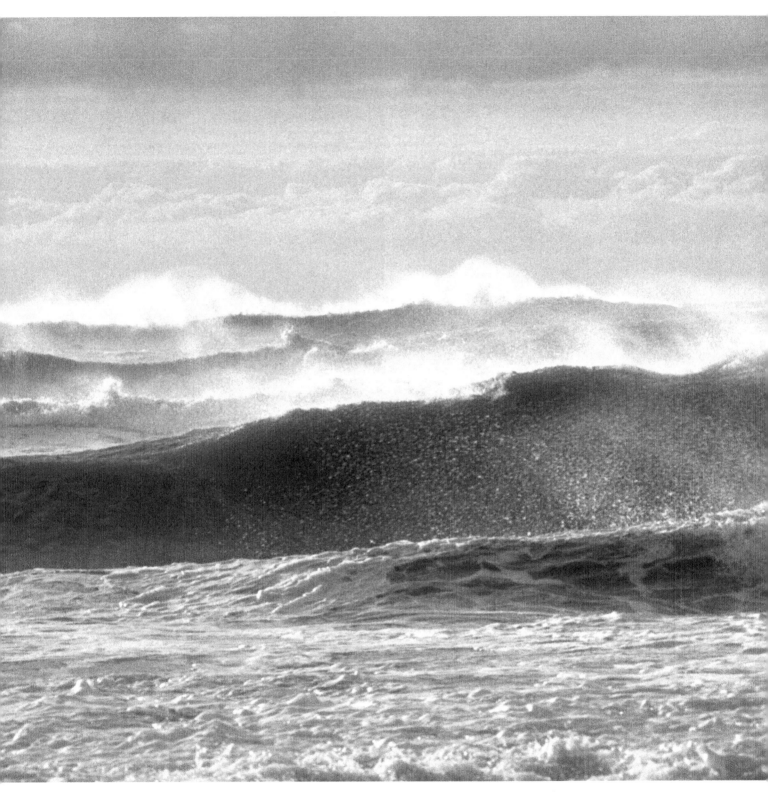

Spray leaps high as wind and waves collide.

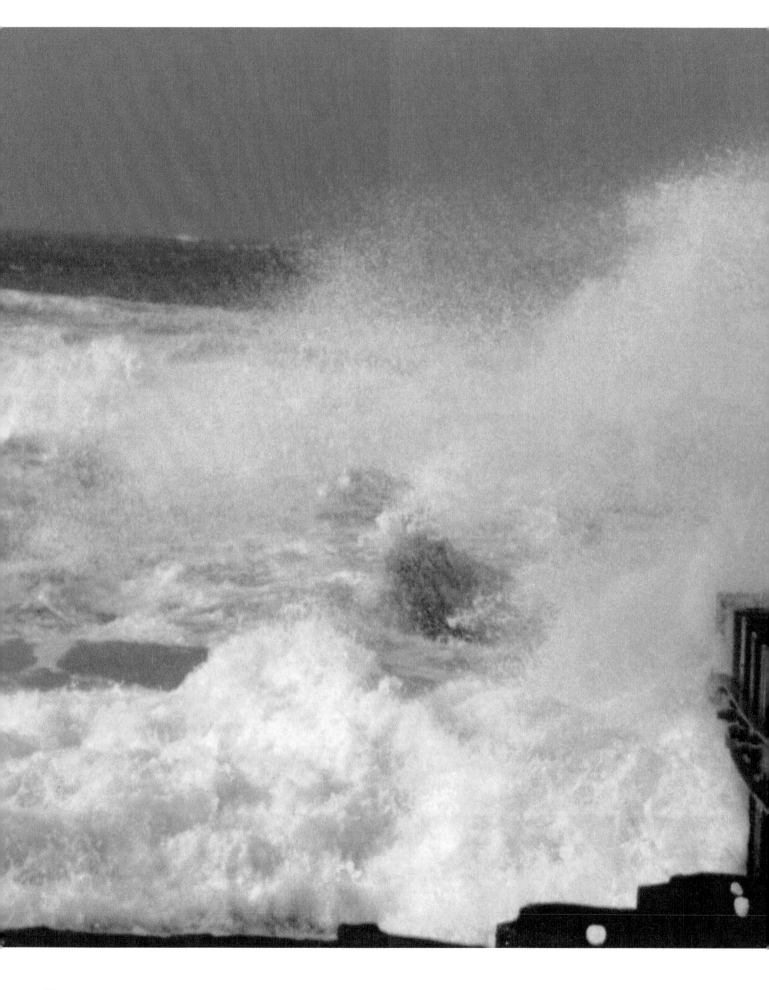

in a futile effort to hide. The lofted sand blasts against windows, pitting the glass; unanchored asphalt shingles flap against the roof, bowing in subservience to the overpowering force of the newfound wind; and trash cans, having waited patiently in their racks for just such a moment as this, leap from their places of confinement, voicing eerie, clattering joy at their release.

And often, just when human ears and senses become attuned to the change, the clouds pass over and rays of sun shine through once more. Again the wind is a breeze, gently whistling through the screens, like a little boy walking a lonely sand trail who has suddenly thrown an uppercut at an imaginary opponent, as if to say, "Look at me. I'm the big boss around here."

Wind can be relentlessly brutal or it can whisper gently on the Outer Banks. Here, the wind slams waves against a groin near the original location of the Cape Hatteras Lighthouse.

THE MOVING SANDS

In Buxton Woods, back from the main roads, there are steep hills covered with a soft matting of grass and moss and woods mold, and overlaid with a lush growth of pine and live oak and dogwood. So at odds do they appear against the bleakness of the nearby sand beaches that one might wonder if somehow they had been lifted by the wind from some other place and dropped there to mock the rampant sea.

As to the mocking of the sea, no one can say—but the rest is true. For these are not hills in the common sense. Rather, they are windblown sand dunes, formed in long-forgotten storms, anchored at first by tenacious shoots of wild beach grass until other vegetation took hold and slowly covered the surface in the initial step of transformation from bleak sand dunes to heavily forested hills.

There may even be, at the base of the tap root of a particular tall pine on a particular hill there in the Buxton Woods, an ancient stump of cedar or oak, shielded from air by the covering of sand and thus preserved through the centuries, the last remaining evidence of a more ancient forest, which in turn had been engulfed and killed by the blowing sands that formed the mound on which that tall pine now stands. For this is a dual process of birth and life, death and destruction, and it will continue as long as there are winds to blow and sands to be blown.

Until recently, man's every effort seemed directed toward abetting the destruction. He cut and burned the lush forest growth that had covered much of this seashore area when the explorers sent out by Sir Walter Raleigh first landed on this coast. Then man

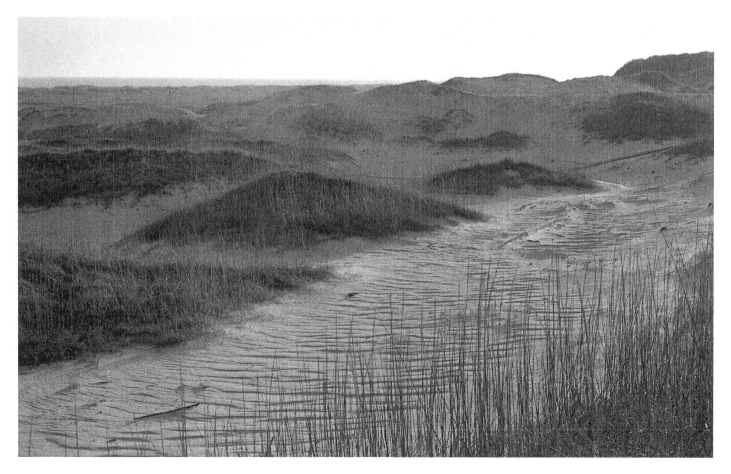

Windblown sand hills are gradually anchored by beach grass and sea oats.

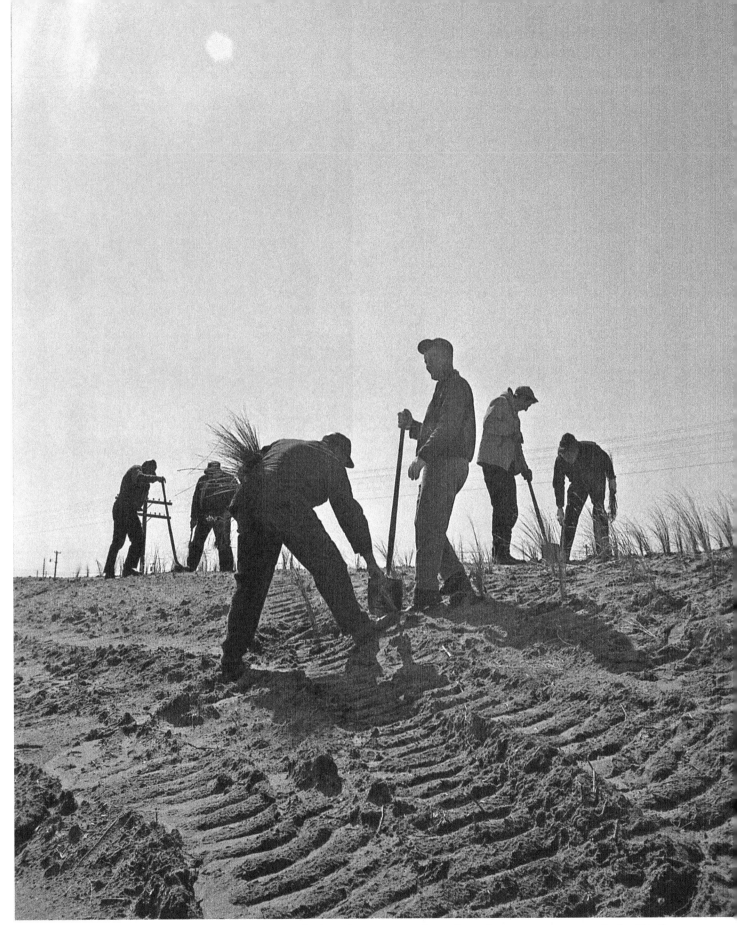

Park Service crews plant beach grass on a newly built dune.

Storm winds blow sand over beach grass near the Cape Hatteras Lighthouse. If sand continues to accumulate, a sand dune is born.

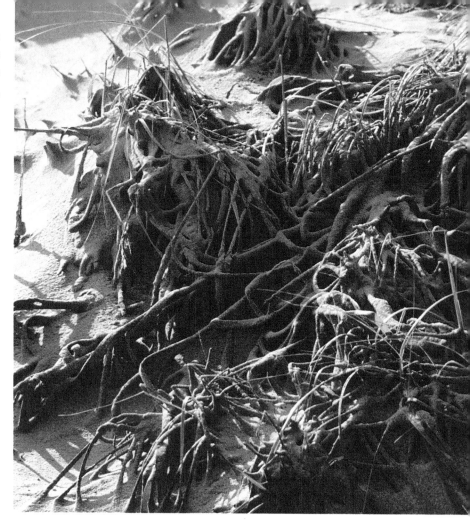

Snow fences halt the blowing sand, forming the base for yet another protective barrier dune.

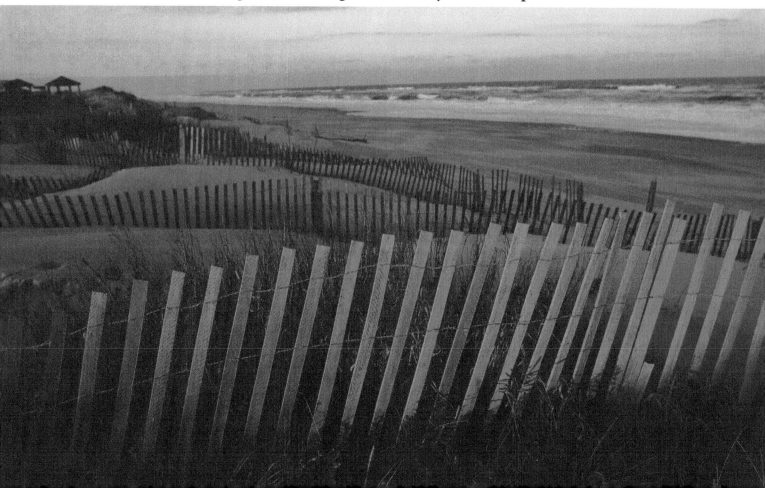

turned loose his stock, keeping the undergrowth and grass cropped down so the wind could reach the sandy soil beneath. Strong northeasters moved the sand inland, piling it up against the remaining trees until they too were covered and choked to death, and the dunes formed into veritable sand waves, moving across the beach, destroying everything in their path. And in many spots, the elevation of these seashore islands was lowered to the point where every strong tide came over, and vast areas became bald and barren beaches, frequently awash.

Lately, strong countermeasures have been initiated, and the Park Service is engaged in a program of sand fixation, dune stabilization, and erosion control. Sand fences were built to catch the blowing sand and build the dunes higher and wider. At first by hand and then with specially designed machines, Park Service crews planted beach grasses, experimented with breeding new and tougher strains, and tried fertilization to speed the growth process. Today, over much of the seashore, the dunes are high and wide, with a vast covering of protective grasses. Even the trees are springing up again to the leeward of the new dune line.

Some claim man is courting disaster by failing to leave floodgates or overflow areas through which storm-driven sound water can pass when hurricane winds force it down into the bight behind the Cape. But none deny that nature and man, working in unison, are stabilizing and reforesting on an unprecedented scale.

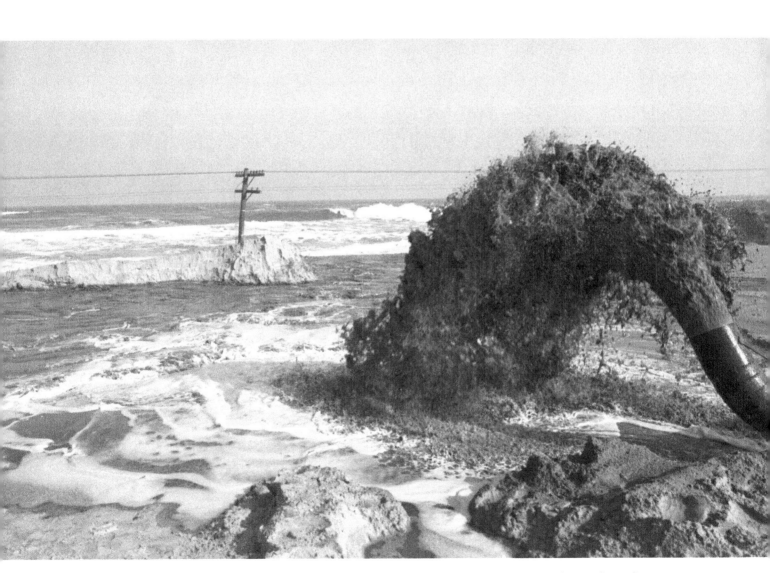

Near the site of the 1962 Buxton Inlet, sand is moved by suction dredge and pipeline from the sound back to the ocean beach.

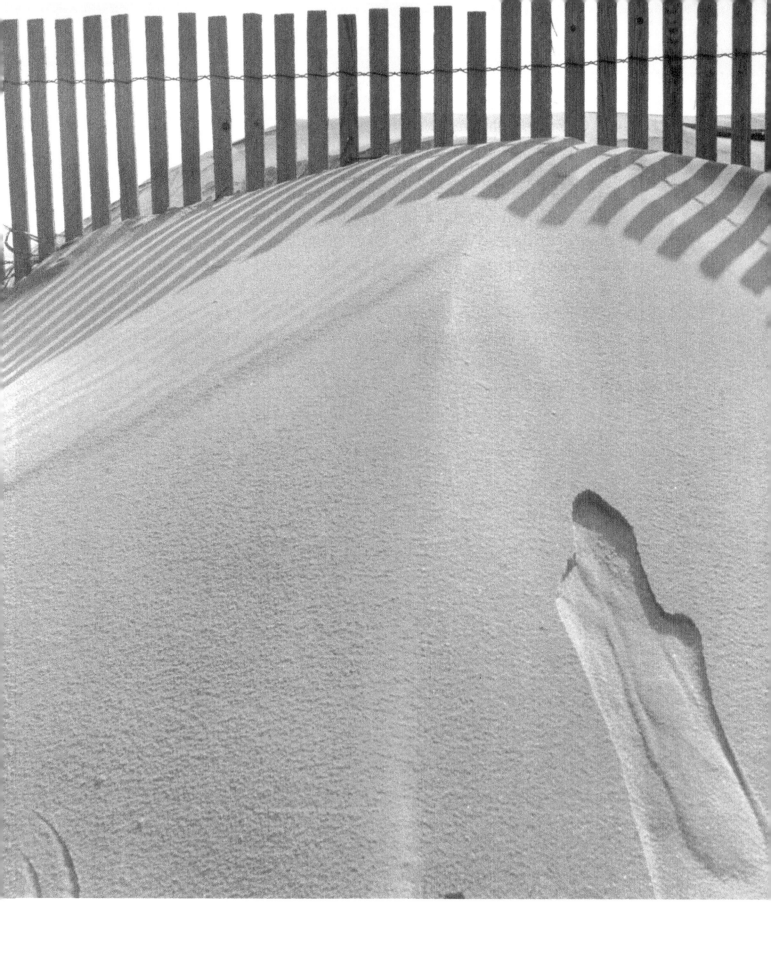

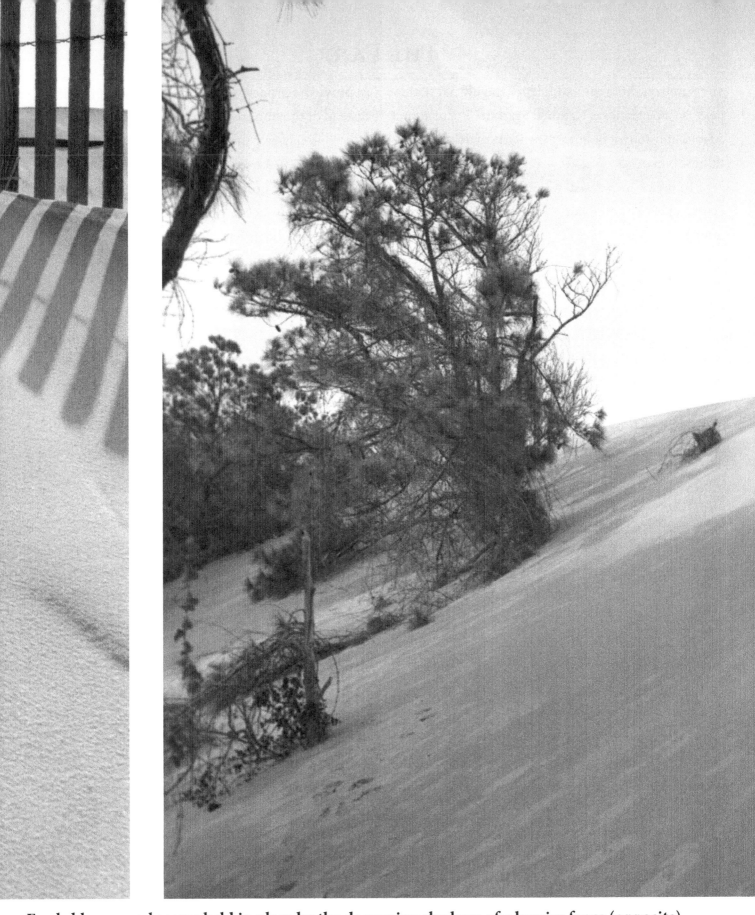

Fresh-blown sand seems held in place by the deepening shadows of a barrier fence (opposite). Such fences are used to combat destruction like that pictured above, where a mountain of sand is engulfing a forest that dares to block its way. Only dead stumps and limbs remain when the migratory dune has passed by on its westward march.

THE PARK

The name on the signs and folders and official stationery is Cape Hatteras National Seashore Recreational Area, but locally it is simply the Park, which is many things to many people.

To the casual tourist, it is museums and visitor centers, history and folklore, uniformed rangers and informed guides.

To the naturalist, it is snow geese and skimmers, gulls and shore birds, each living undisturbed in its natural habitat.

To the conchologist, it is seventy-five miles of undisturbed and accessible ocean frontage and a multitude of seashells just waiting to be found.

And to the camper, it is heaven—with an occasional taste of sand in his sandwich.

But it is more than that.

To the game fisherman, it is game fish junction, the land of world-record channel bass or red drum, of the seasonal runs of bluefish and stripers, of northern weakfish and southern weakfish, mackerel and flounder, sea mullet and cobia.

To the commercial fisherman, hauling his nets on the ocean beach, it is uniformed rangers enforcing the rule that dead fish and scrap cannot be left on the shore.

To the beach buggy operator, it is that same ranger—or another with equal authority—a traffic cop in the wide open spaces who tells you where to drive and how to drive and won't let you tear over the dunes, which is what the buggy was designed for in the first place.

To the property owner whose property he no longer owns because it was condemned for park use, it is government interference in private enterprise and often a lengthy lawsuit in federal district court to prove the property is worth half a million dollars instead of the hundred thousand the government offered to pay—or the twenty-nine hundred it cost back in the 1930s.

And to the property owner who sold the government his ocean frontage and is trying to run a business on what is left, it is a sometimes-benevolent, sometimes-stern guardian, ever present in the background.

But it is still more, even, than that.

It is money in the bank.

It is steady jobs and income for a sizable segment of the population—civil service status for a large number of foremen and laborers, stenographers and file clerks, rangers and seasonal help, and even an occasional local historian or naturalist or desk-job supervisor.

It is nationwide publicity for a growing resort area whose economy to a large extent depends on publicity.

It is built-in government assistance in getting bridges constructed, harbors dug, and inlets filled.

It is man-made protective sand dunes, covered with hand-planted beach grass, backed up by nursery-grown seedlings, all installed by the government with millions of dollars of federal funds, in areas where before the beach was flat and eroded and often not suitable for human habitation or development by those who owned it.

But most important of all, it is the nation's first national seashore recreational area, owned by all of the people, controlled by the agents of all of the people, and preserved largely in its natural state for the perpetual use of all of the other people who will follow.

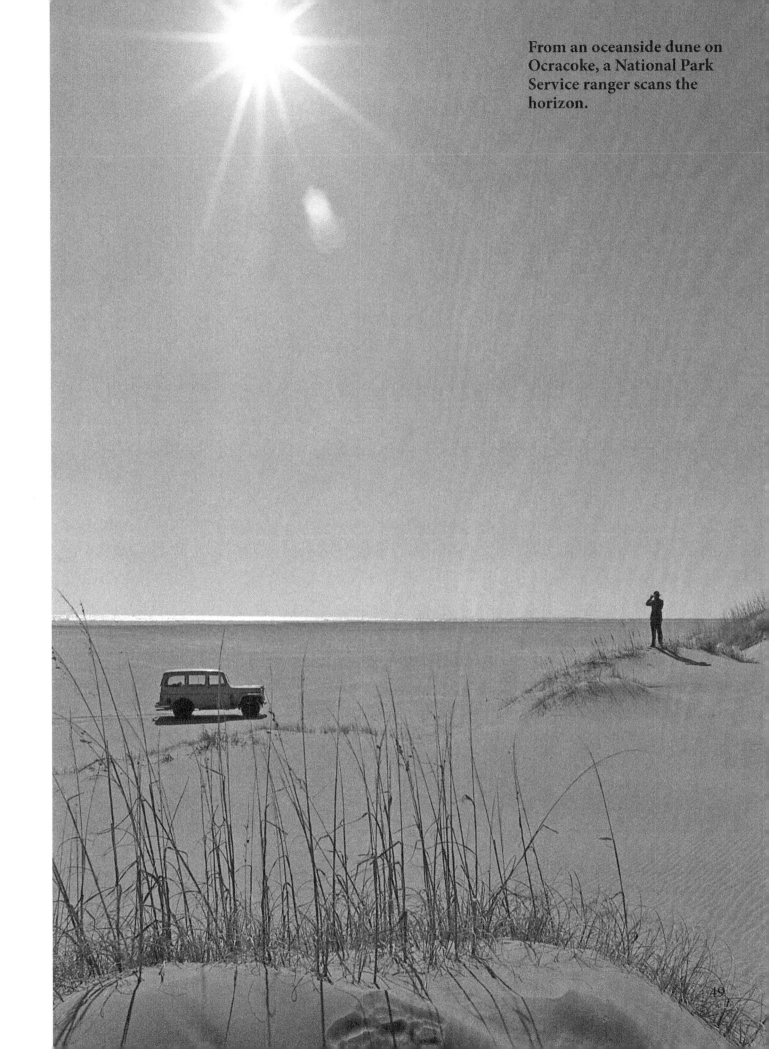

From an oceanside dune on Ocracoke, a National Park Service ranger scans the horizon.

49

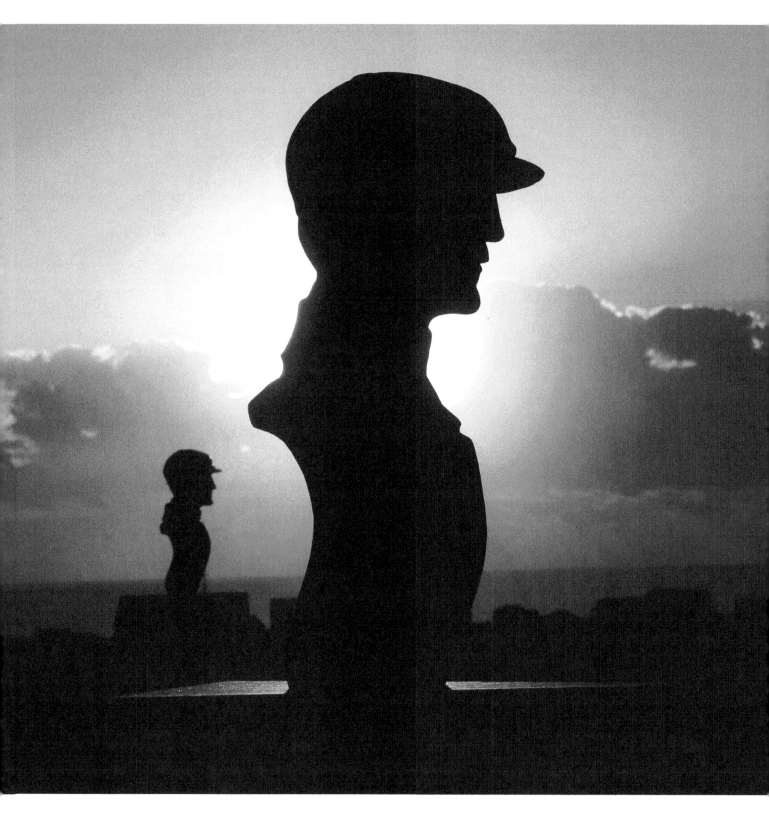

For hours on end at Kitty Hawk, the Wright Brothers studied the flight of birds—and then went on to fly themselves. This 1933 monument marks man's conquest over gravity and his taking to the air.

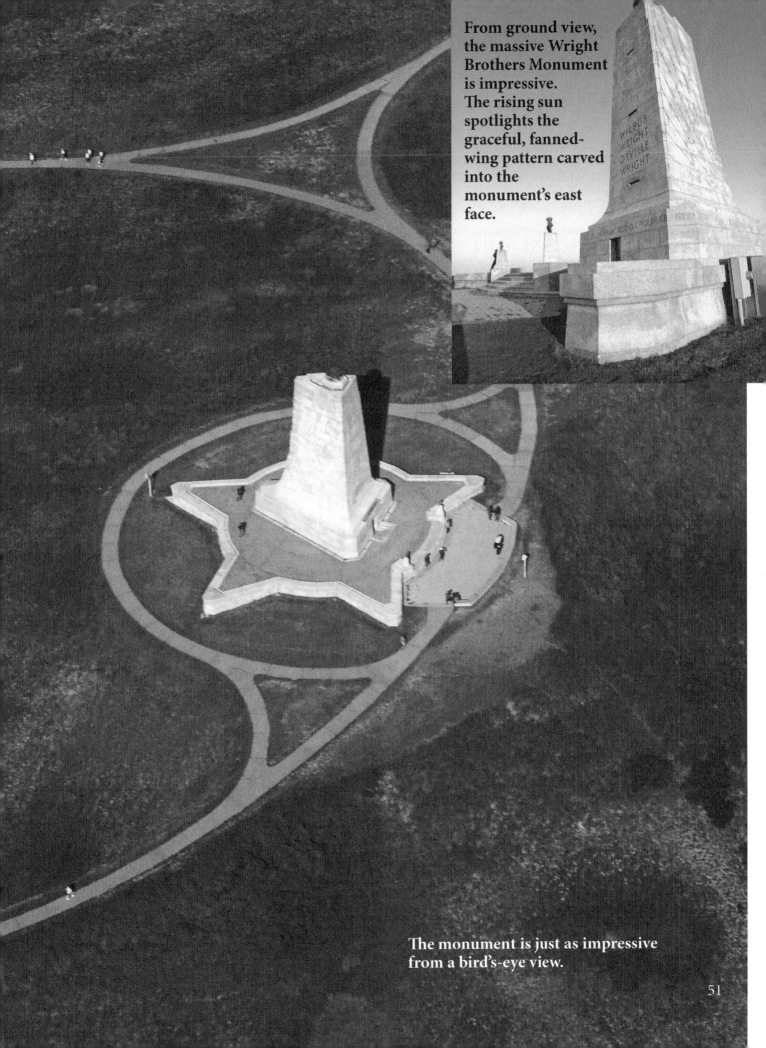

From ground view, the massive Wright Brothers Monument is impressive. The rising sun spotlights the graceful, fanned-wing pattern carved into the monument's east face.

WILBUR
WRIGHT
ORVILLE
WRIGHT

The monument is just as impressive from a bird's-eye view.

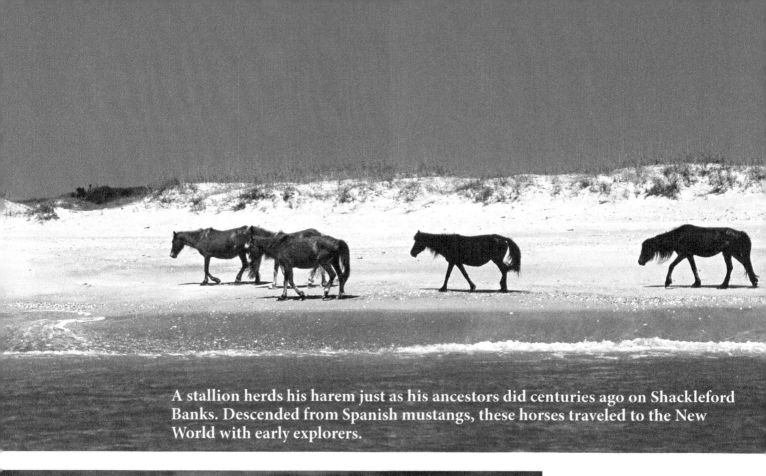

A stallion herds his harem just as his ancestors did centuries ago on Shackleford Banks. Descended from Spanish mustangs, these horses traveled to the New World with early explorers.

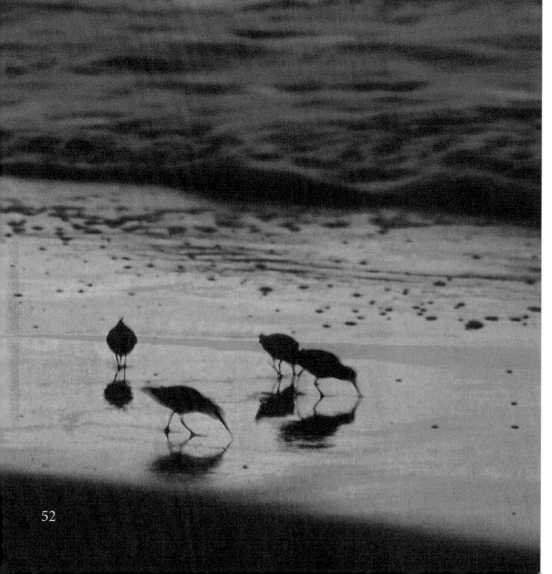

Sanderlings look for breakfast as the first rays of sunlight break over the shores of Hatteras Island.

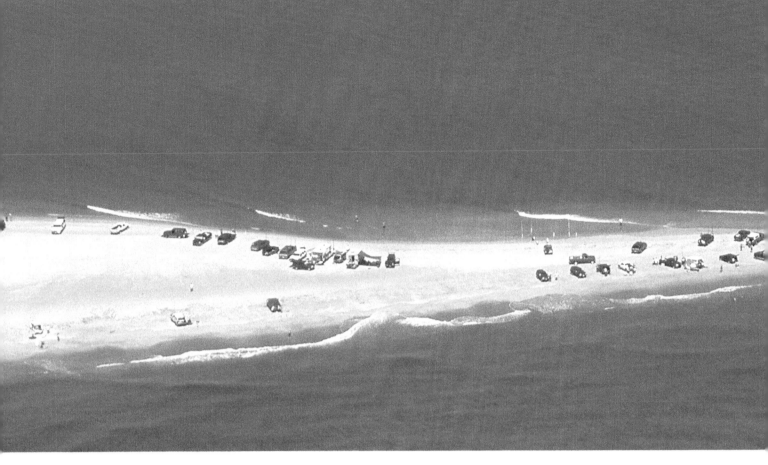

Fishermen's cars are parked all the way to the tip of Cape Point near the Cape Hatteras Lighthouse in Buxton. This is considered by many to be the best coastal fishing spot for hundreds of miles. The collision of a cold current flowing south and the warm Gulf Stream tracking north draws fish in abundance. Generations of Hatteras islanders have made fishing here a time-honored tradition. A fisherman had best watch his truck as high tide rolls in.

Thousands of snow geese return to Pea Island National Wildfowl Refuge each fall from their breeding grounds in northern Greenland.

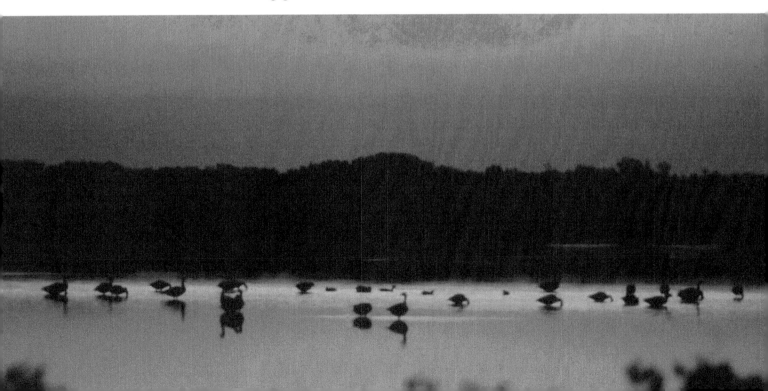

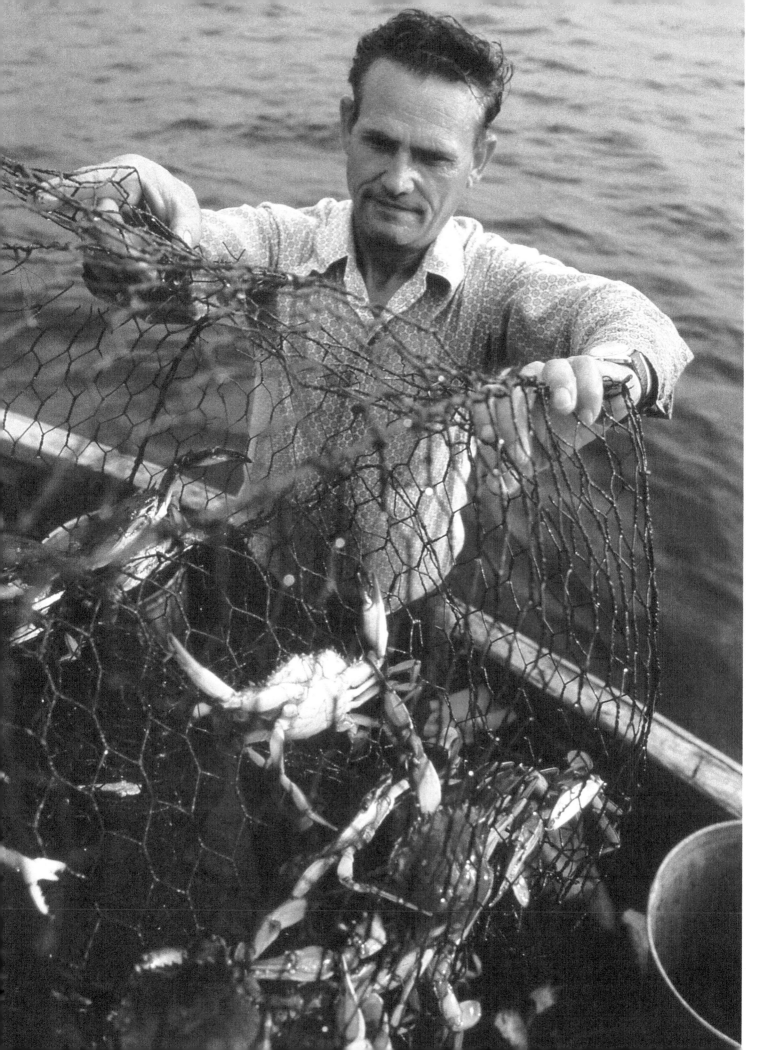

THE WAY OF LIFE

There are basic differences, both subtle and certain, between the people who inhabit these seashore islands and their mainland cousins across the sound.

It is not that the women are prettier, as some claim (though the islands have produced their share of beauties), or that the men are stronger or more rugged. Nor is it just a matter of the distinctive speech, which some twentieth-century visitors have sworn is pure sixteenth-century Elizabethan English.

It is more than that. It is a way of life, inherited and inbred, the direct and inevitable result of two and a half centuries of isolation. And it is manifest in many ways.

Start with the names.

One colonial Carolinian described the earliest residents as an independent set of people, living on "ye sand banks on ye sea shore," and it was not long before they were widely known as "bankers," a term few of them ever use and some seem secretly to detest.

Where else would you find the old, abandoned village of Little Kinnakeet (spelled with an *i),* formally located in Kennekeet Township (spelled with an *e),* or a Coast Guard facility officially designated the Chicamacomico Lifeboat Station?

An occasional Smith or Jones may show up, but to the new arrival, every other person seems to be named Midgett, and the non-Midgett is almost certain to be a Meekins, Austin, or Gray, a Ballance, Burrus, or Scarborough, or closely related to one of these.

Elsewhere, self-sufficiency may be a sociological term, but here through the centuries it has been an essential character trait in constant evidence. No matter what occupation a man claimed as his own—stockman or boatman, fisherman or pilot—he was also a carpenter and mason, sailmaker and boatbuilder, farmer and mechanic. And every woman was expected, as a normal adjunct of her duties as housewife, to turn seamstress and nurse, canner and beautician, teacher and counselor as the need arose.

For centuries, this was an open range where cattle, beach ponies, hogs, and sheep roamed at will, their strain toughened by exposure to the elements and subsistence on sparse beach grass. The annual penning,

when the stock was rounded up and marked, was an eagerly awaited occasion, with the average banker man turning cowboy for a day, his wife producing culinary masterpieces for a giant, collective grub-on-the-ground feast, and off-island relatives returning for homecoming.

When it came to law and justice, state statutes and federal laws were fine—anywhere else, that is. Policemen enforced the laws, and jails and jailers incarcerated the offenders. But here the encircling sea was jailer, and each neighbor was enforcer of an accepted code of behavior, peculiarly adapted to the needs of the seashore community.

If seawater did not really run in the veins of these people, then there must have been at least a high salinity level in their blood. Men who could not swim—and a high proportion could not—lived for days on the water, loving and hating it at the same time. And many offered their lives, in a profession aptly named the Lifesaving Service, to rescue other mariners they did not know who hailed from ports they had never heard of.

For excitement, can there be anything to rival a shipwreck? The mere sight of a seagoing vessel stranded high on the beach after a storm was an experience not soon forgotten. The teamwork and proficiency of an experienced lifesaving crew, launching their surfboat through pounding breakers or setting up their breeches buoy to haul survivors ashore, was a spectacle no more than equaled in this modern day by astronauts. But the climax of any shipwreck was the vendue, or auction sale, when the wreck master disposed of what was left of ship and cargo: bales and boxes concealing exotic merchandise; cabin doors and windows and fancy molding to dress up a new home on a soundside hummock; tools and drapes and sometimes clothing.

This is what two and a half centuries of isolation brought. And this is what a single generation of dramatic changes—roads and bridges, radio and television, tourists and promoters—is fast supplanting with conformity and sameness. We call it progress.

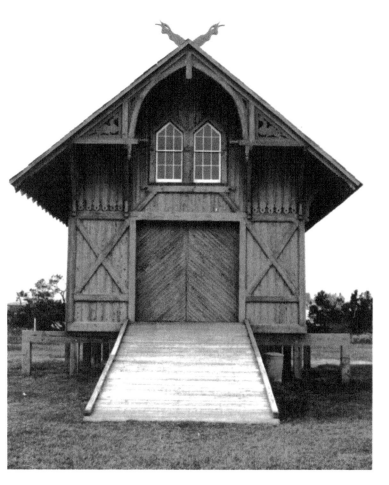

HISTORY STANDS

There is not even one nail in this original 1874 lifeboat building at the Chicamacomico Lifesaving Station in Rodanthe. It is put together entirely with wooden pegs. Even more unusual are the Gothic windows and board-and-batten style; it is almost identical to a structure in Cannes, France, built in 1032. "The architect had toured France while sketching favorite buildings and put them into a composite building," said Ken Wenberg, the official restorer of the lifesaving station. Becoming a lifesaving surfman was a popular career for many Outer Bankers during the late 1800s through the early 1900s.

A FAMOUS RESCUE

Inside the lifeboat building is Surfboat No. 1046, which was used in a famous rescue during World War I. On August 16, 1918, the British tanker *Mirlo* was torpedoed by the German submarine *U-117* while it carried a load of high-octane aviation fuel seven miles north of Cape Hatteras. Chicamacomico Lifesaving Station Keeper John Allen Midgett and his five-man lifesaving crew launched this self-bailing surfboat, weaved among burning slicks of gasoline and oil for six hours, and rescued forty-two of fifty-one British sailors off the blazing ship. The U.S. Coast Guard and the British government awarded Medals of Honor to Captain Midgett and his crewmen for their exemplary heroism.

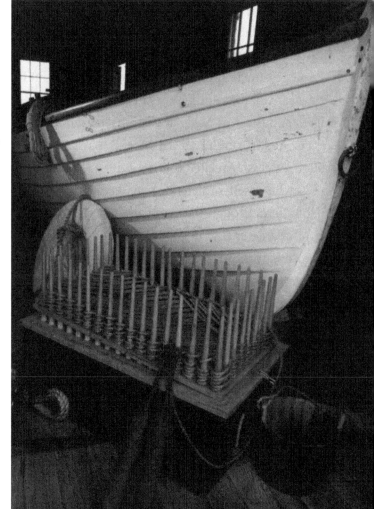

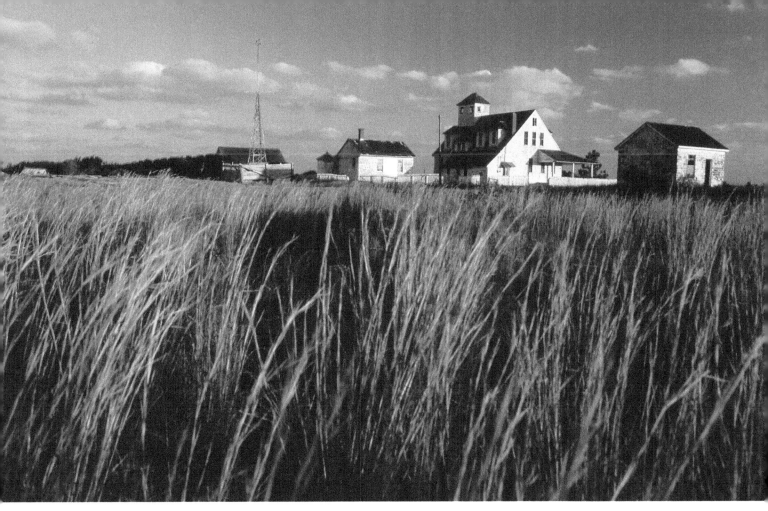

The Chicamacomico Lifesaving Station marks a dangerous area of the coast and has been the scene of many daring rescues. The station has been renovated since this photo was taken.

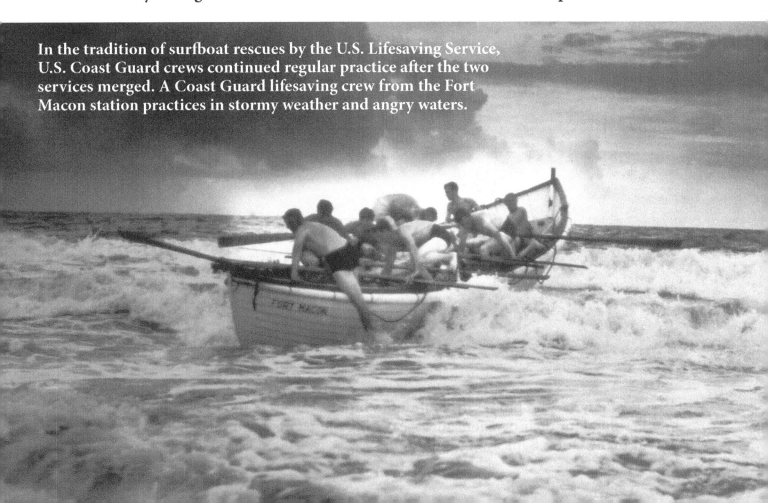

In the tradition of surfboat rescues by the U.S. Lifesaving Service, U.S. Coast Guard crews continued regular practice after the two services merged. A Coast Guard lifesaving crew from the Fort Macon station practices in stormy weather and angry waters.

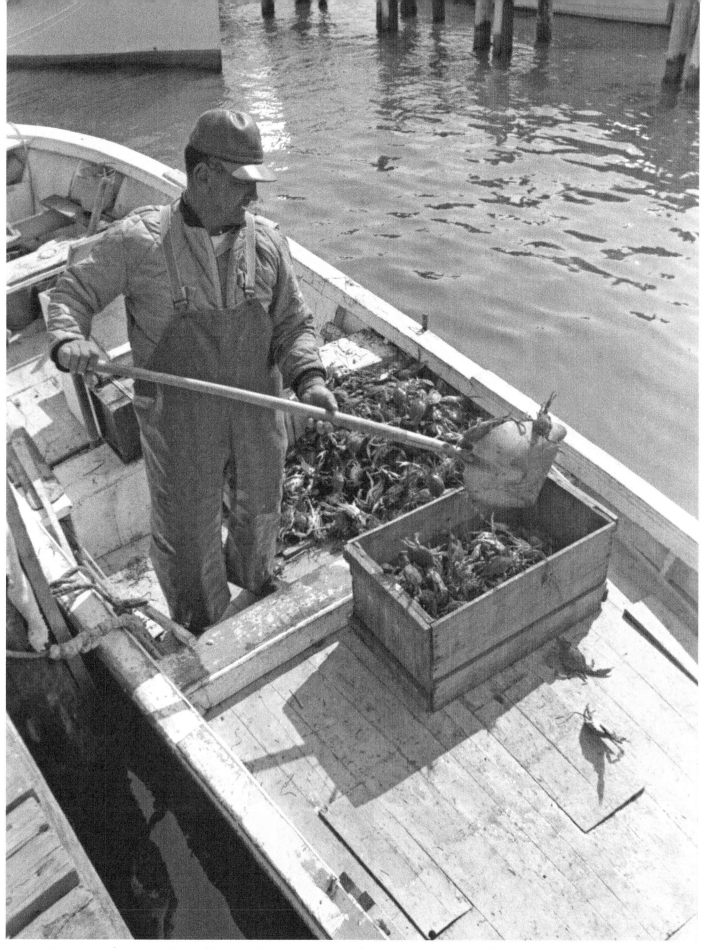

A crate of pugnacious blue crabs is about to find its way to market. Because the crabs are highly valued for their delicious meat, catching these gifts from the sea has been a way of life for many Outer Banks watermen.

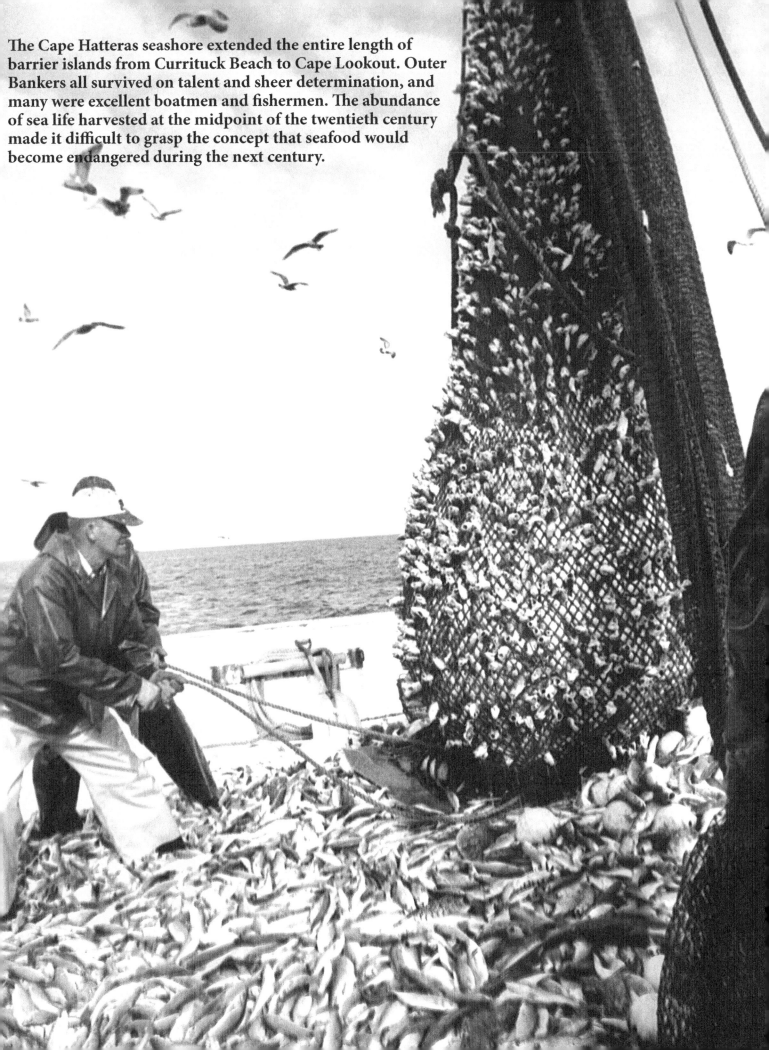

The Cape Hatteras seashore extended the entire length of
barrier islands from Currituck Beach to Cape Lookout. Outer
Bankers all survived on talent and sheer determination, and
many were excellent boatmen and fishermen. The abundance
of sea life harvested at the midpoint of the twentieth century
made it difficult to grasp the concept that seafood would
become endangered during the next century.

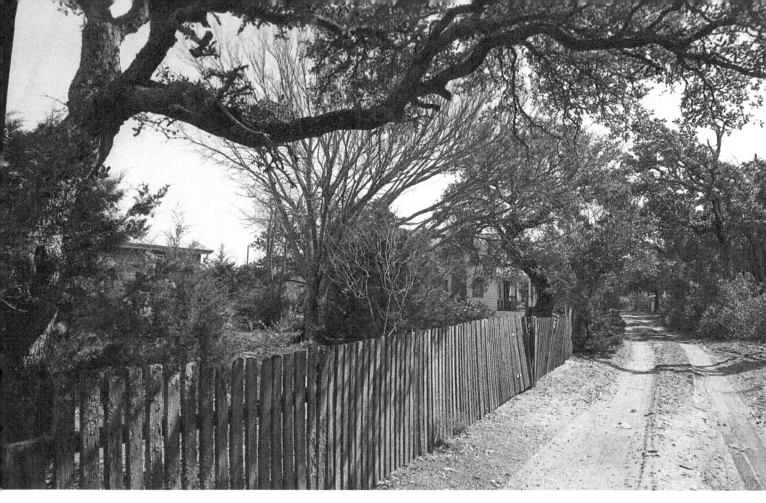

Picket fences, some of plain weathered
board and others carved decoratively
and painted, are a part of the Ocracoke
landscape. Here we see one alongside
a meandering village street, another
enclosing the British Cemetery.

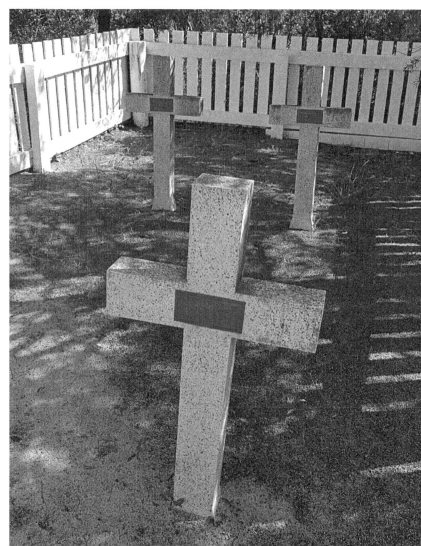

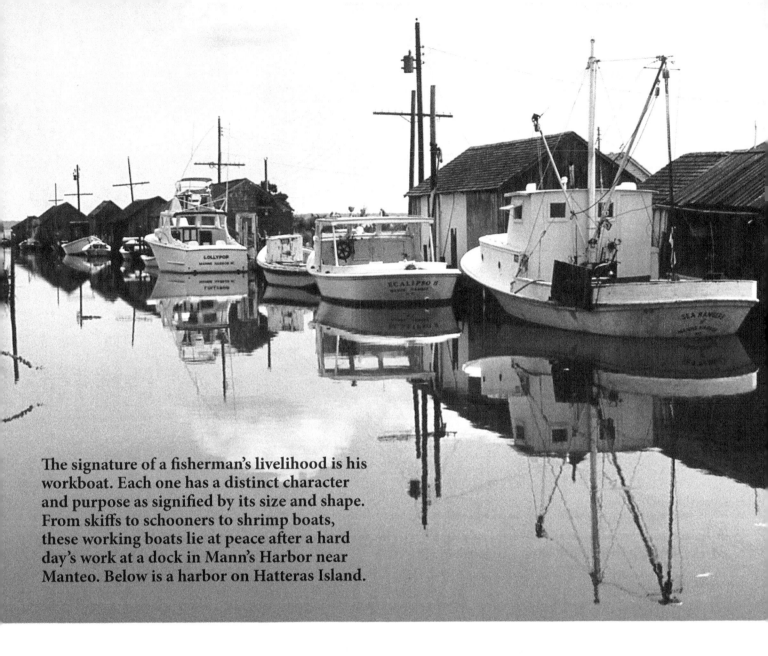

The signature of a fisherman's livelihood is his workboat. Each one has a distinct character and purpose as signified by its size and shape. From skiffs to schooners to shrimp boats, these working boats lie at peace after a hard day's work at a dock in Mann's Harbor near Manteo. Below is a harbor on Hatteras Island.

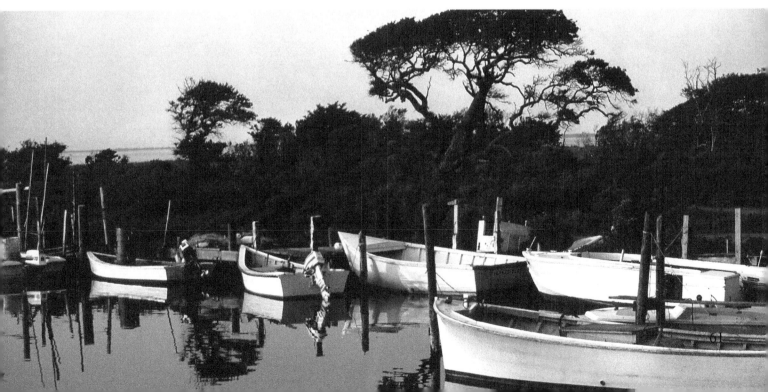

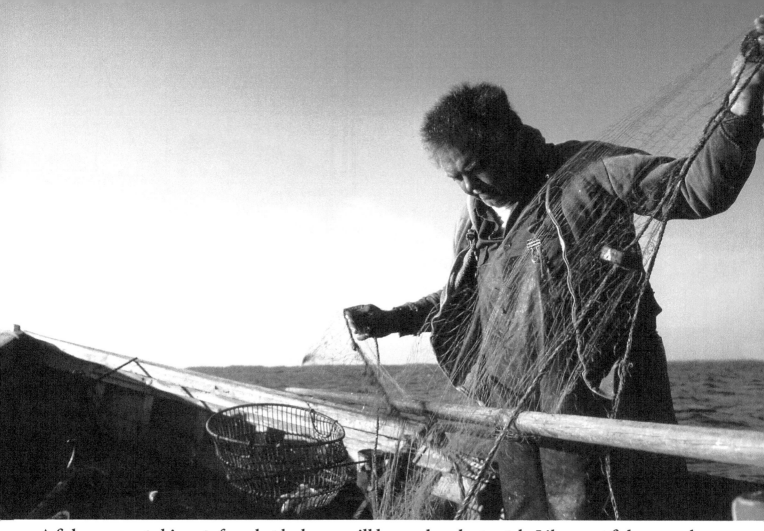

A fisherman sets his nets for what he hopes will be an abundant catch. Like most fishermen, he works alone in his boat, often miles from shore.

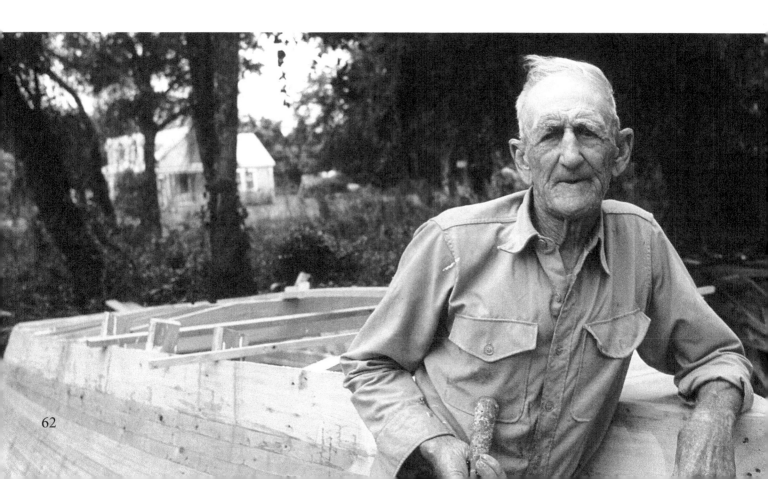

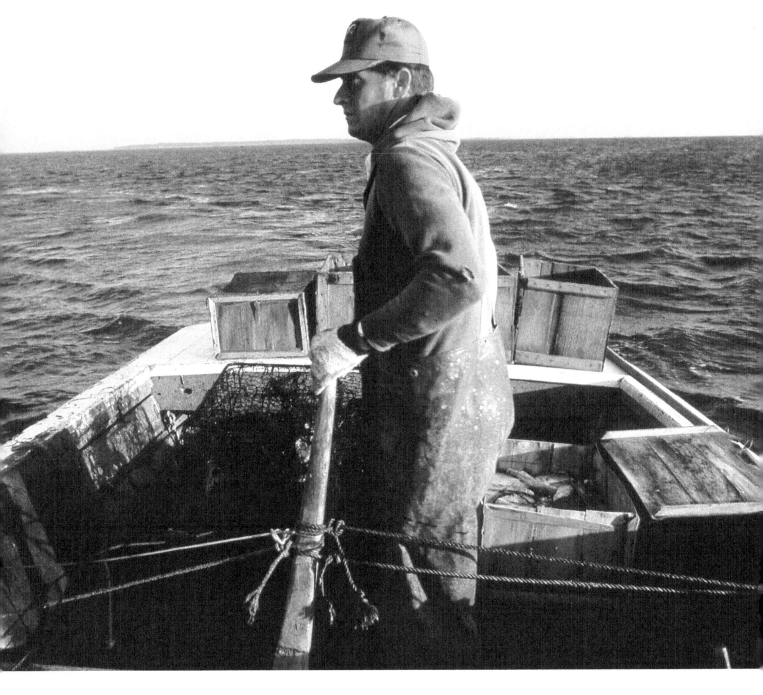

A fisherman's life is as tethered to the sea as his tiller is to his boat. The job of checking crab pots and hauling in fish must be done in dark of early morning and dark of evening, rain or shine, frigid temperatures or searing heat. No doubt this fisherman learned his trade as soon as he could stand in his father's boat.

At the southern terminus of the barrier islands, on Harkers Island near Cape Lookout, Stacy Franklin Guthrie (opposite), with his rugged hands, represents the proud traditions of boatbuilder, decoy carver, and fisherman.

Here are some other books from Pineapple Press on related topics. For a complete catalog, write to Pineapple Press, P.O. Box 3889, Sarasota, Florida 34230-3889, or call (800) 746-3275. Or visit our website at www.pineapplepress.com.

Just Yesterday in North Carolina, Second Edition, by Bruce Roberts. Prize-winning photographer Bruce Roberts has assembled a treasure trove of photos and stories that epitomize North Carolina from the 1950s to . . . just yesterday. Catch a glimpse of simple farmers and farmhouses, lighthouses, Civil Rights demonstrations, kids in orphanages, country doctors, tranquil nature scenes, and the everyday people of North Carolina's past. This collection of stunning color and black-and-white photos will make you long for a simpler time when old men played checkers on the sidewalk, farmers walked the streets of downtown in their overalls, and old general stores sold everything from penny candy to charcoal grills.

Shipwrecks, Disasters & Rescues of the Graveyard of the Atlantic and Cape Fear, Second Edition, by Norma Elizabeth and Bruce Roberts. Covering a period of about 200 years—from 1750 to 1942— this slim volume highlights the most famous shipwrecks and sea disasters that occurred off the coast of North Carolina. In the mid eighteenth century, a fleet of Spanish galleons and frigates loaded with gold coins and a variety of goods wrecked off Cape Hatteras during a hurricane. During 1942, German U-boats sank more ships off the Outer Banks than the Japanese sank at Pearl Harbor in 1941. Filled with color and black-and-white historical illustrations and contemporary photographs, this is a treasure trove of facts and details about these wrecks and rescues.

Coastal North Carolina, Second Edition, by Terrance Zepke. Steeped in history and full of charm, North Carolina is a must-see destination. This guide is filled with quick histories, calendars of events, lists of attractions, and helpful maps.

Lighthouses of the Carolinas by Terrance Zepke. Eighteen lighthouses aid mariners traveling the coasts of North and South Carolina. Here is the story of each, from origin to current status, along with visiting information and photographs.

Lighthouse Families, Second Edition, by Bruce Roberts and Cheryl Shelton-Roberts. What was it like to live and work at a lighthouse during the heyday of shipping and fishing? Filled with first-person accounts and loads of family photos, this is a record of the memories and stories of America's lighthouse keepers.

Lighthouse Ghosts, Second Edition, by Norma Elizabeth and Bruce Roberts. Here are 13 tales of specters that haunt lighthouses from California to Massachusetts, Michigan to Florida. Meet the lighthouse keepers who took their obligation so seriously that they continue to make their rounds and keep the lights burning long after they're gone.

Lighthouse Ghosts and Carolina Coastal Legends, Second Edition, by Norma Elizabeth and Bruce Roberts. From the Graveyard of the Atlantic to beautiful Hilton Head Island, lighthouse legends abound. A black pelican, a "gray" man, and a young girl with misty-blue eyes have been warning locals of hurricanes for centuries. Includes complete visiting information with phone numbers, addresses, and websites.

CPSIA information can be obtained at www.ICGtesting.com
Printed in the USA
BVOW10s0121230414

351420BV00005B/24/P